HIDDEN
HISTORY
of
CINCINNATI

HIDDEN
HISTORY
of
CINCINNATI

Jeff Suess

THE
History
PRESS

Published by The History Press
Charleston, SC
www.historypress.net

Copyright © 2016 by Jeff Suess
All rights reserved

Portions of the text appeared previously in the *Cincinnati Enquirer*.

Front cover: courtesy of the Cincinnati Enquirer/*Lawrence J. Neumann.*
*Back cover, top: courtesy of the Library of Congress/*Harper's Weekly; *bottom: courtesy of the* Cincinnati Enquirer *archives/Richard K. Fox.*

Opposite: The eastern skyline of Cincinnati in 1866, highlighted by the First Presbyterian Church reaching for the sky, shows the Queen City as she was heading into her defining decades. *Courtesy of the* Cincinnati Enquirer *archives.*

First published 2016

Manufactured in the United States

ISBN 978.1.46711.989.4

Library of Congress Control Number: 2016942428

To Mom and Dad—with love.

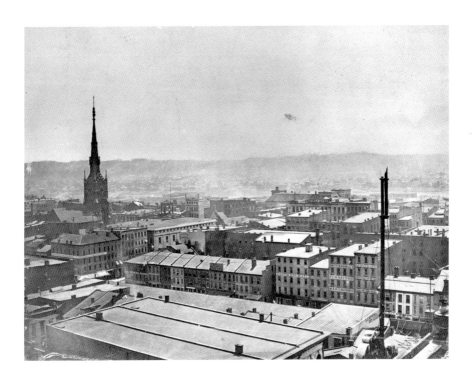

CONTENTS

CONTENTS

ACKNOWLEDGEMENTS

History projects are collaborations built on the meticulous work and great care of those historians and researchers who came before; of the librarians who index and save; of the reporters and photographers who witnessed and recorded; and, lastly, of the men and women who lived our history. None of this would be possible without any of you. You have my sincere gratitude.

Many thanks to my editor, Krista Slavicek, and the folks at The History Press; to Rick Green and Peter Bhatia at the *Cincinnati Enquirer*; to my friends and family for their love and support; to Luann Gibbs and Debbie Radel for invaluable research; to Bonnie Speeg for sharing Mary Jane's story; to Angie Lipscomb, the *Enquirer* and staff, Kevin Grace, Lily Birkhimer and Ohio History Connection, and Diane Mallstrom and the Public Library of Cincinnati and Hamilton County for the use of photographs; to Tina Wyeth Baker, E.R. Bellinger, Lisa Gillespie, Dic Gross, Michael B. Gunn, Anna K. Heran, Jennifer Koehler, Tamera Lenz Muente, Brian Powers, William F. Romain, Jim Schaffer, Christopher Smith, Corky Steiner, William Styple, Jeremy Suess and Jeff Wyeth for their help; to Harry Pence, Roscoe Eads, Fred Morgener, Ray Zwick, Sally Besten and Frank Harmon; and to my beloved Kristin and Dashiell, you make it all worthwhile.

INTRODUCTION

What exactly is hidden history? Certainly there are things we can never know, facts lost to time. Much more has been recorded than we may realize, and we can trace our history if we dig deep enough and know where to look. Yet, history can also be buried and forgotten, or purposely erased, or just never noticed. There is some of all that in here. Someone can be famous one day, a faded memory the next. Or they may not fit the narrative of history. We may not recognize the extraordinary in the ordinary until some time has passed. Then we need something—a historical marker, a blog post, a book—to spark our curiosity to know more.

There are hundreds of such stories in Cincinnati's history. Here are some that deserve more attention—people and events that should be revealed, honored and remembered. These are stories of bravery, fortitude, ambition and tragedy; of humor, whimsy, conflict and creation. They belong to Cincinnati but also reach beyond the city, touching on baseball and toys, on celebrities, on civil war and on hardy pioneers. At the heart, these are stories of real people—and a few birds—who are worth knowing. I can't wait to introduce you.

PART I

EARLY DAYS

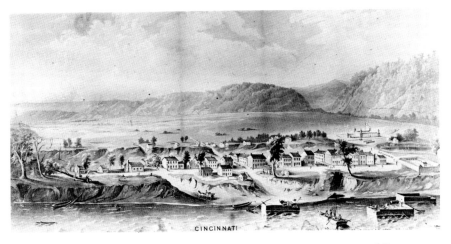

Cincinnati in 1802 was a small town on the western frontier. The placement of Fort Washington (at rear right) helped establish Cincinnati as the dominant settlement in the West. *Courtesy of the* Cincinnati Enquirer *archives.*

THE SERPENT MOUND

The history of a region typically begins at the recorded events. In the case of Cincinnati, that's what was chronicled by European settlers starting in the eighteenth century. Earlier events are relegated to study by archaeologists, anthropologists and geologists. But, really, it is all history. The study of what transpired before the first white men trekked to the area, and even those early days of settlement, lead to new discoveries that help us solve the mysteries of the past.

In geological terms, the Cincinnati topography was formed over eons by the invasions of three glaciers. Two million years ago, in the Pleistocene epoch known as the ice age, the land where Cincinnati sits was flat, with a meandering north-flowing river that geologists call the Teays River. The Kansan glacier advanced from the north 1.2 million years ago, stopping at northern Kentucky before retreating. The ice sheet created a great lake that, over hundreds of thousands of years, eroded a deep valley about one hundred feet lower than the Ohio River today. Two more glaciers, the Illinoian (400,000 years ago) and the Wisconsinan (70,000 years ago), left deposits within the deep valley, creating shelves of rock and clay that formed the region's hills and the basin in which Cincinnati was settled. The melted ice forged the west-flowing Ohio River.

Spear points as much as 12,000 years old indicate that the earliest occupants in Hamilton County were Paleo-Indians. But three later native cultures were the predominant settlers in the area. The Adena people lived in southern Ohio from 800 BC to AD 100, during the Early Woodland period. They

were noted for burying their dead in mounds left as territory markers. The Hopewell, also mound builders, followed from 100 BC to AD 400. They had an interest in geometry and astronomy, evident in their earthworks. The Fort Ancient culture occupied the area from AD 1000 to 1650.

Indian mounds are concrete evidence of the ancient peoples who would have roamed the same grounds that Cincinnati lies on today. There were several Adena burial mounds in what is now Hamilton County, from Sayler Park to Indian Hill, though most have been obscured or erased by development. Elliptical burial mounds were identified throughout the Cincinnati basin, from Fifth Street to Liberty, by early Cincinnatians Daniel Drake, William Henry Harrison and Robert Clarke. But there was no real attempt to preserve the mounds as the city grew on top of them. Drake described the largest mound in the center of the city in 1815:

> It is a very broad ellipsis; one diameter extending 800 feet east from Race-street; and the other about 660 feet south from Fifth-street….On the east side it had an opening nearly 90 feet in width. It is composed of loam, and exhibits, upon being excavated, quite a homogenous appearance. Its height is scarcely three feet, upon a base of more than thirty. There is no ditch on either side. Within the wall, the surface of the ground is somewhat uneven or waving; but nothing is found that indicates manual labor.[1]

The most prominent and intriguing prehistoric earthwork in the region is the Serpent Mound, located about seventy miles east of Cincinnati in neighboring Adams County. No one knows who built the effigy mound, perhaps the world's largest, or when. Archaeologists studying the site have theorized based on available evidence, but even the authorities are not in agreement.

Early archaeologists Ephraim Squier and Edwin H. Davis of Chillicothe, Ohio, first documented the Serpent Mound in 1848 in their landmark book *Ancient Monuments of the Mississippi Valley*, the first publication by the Smithsonian Institute. Until then, the earthwork located on a bluff overlooking Brush Creek had been known by only the local rural inhabitants. Squier and Davis's map and description identified the raised dirt mound as a serpent, an undulating line with a coil at one end and a triangular "head" at the other, along with a second oval shape.

The Serpent Mound was not immediately protected. A tornado in 1859 wiped out the trees on the mound, and the landowner, John J. Lovett, cultivated the site for a few years, letting his livestock graze there. Frederic

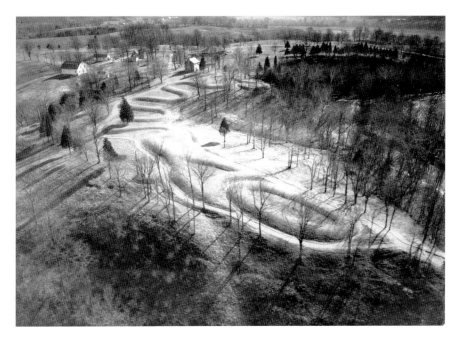

The enigmatic Serpent Mound has intrigued archeologists and anthropologists trying to uncover the mysteries of the region. *Courtesy of Ohio History Connection.*

Ward Putnam of the Peabody Museum of Archaeology and Ethnology at Harvard University first visited and photographed the Serpent Mound in 1883. Concerned about vandals and erosion, he raised funds for the museum to purchase the land in 1887 and preserve the site. Putnam conducted thorough investigations of the effigy mound, then carefully restored it by repacking dirt that had washed down from the embankments. In 1900, Harvard deeded the Serpent Mound to the Ohio State Archaeological & Historical Society, now known as Ohio History Connection, which continues to own the site.

The Serpent Mound measures about 1,370 feet in length, including the oval and a triangular feature on the other side of the oval, and ranges from 1 to 4 feet in height. The geoglyph unmistakably depicts a serpent, possibly a connection to the Great Horned Serpent of Native American mythology, but there is little agreement about what the oval represents. It has been suggested as an egg or sun being swallowed by the serpent, or perhaps the serpent's eye.

Early archaeologists thought the Serpent Mound was constructed by the Adena culture, as Adena burial mounds were found near the location.

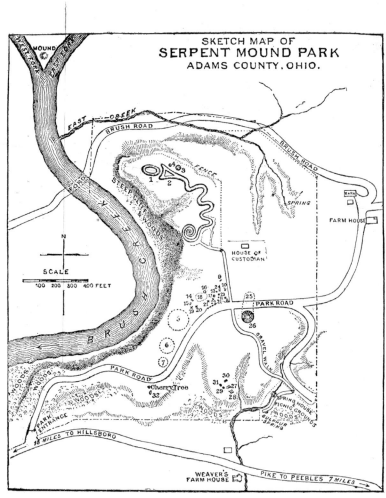

1, The Oval Embankment in front of the serpent's mouth. In this inclosure is a small mound of stones. 2, The Serpent. 3, A low Artificial Mound near the head of the serpent. 4, A very small Artificial Mound just west of 3. 5, 6, 7, Ancient Excavations, appearing like sink-holes. 8, 19, 20, 21, 22, 23, 24, and in space bordered by 18, 15, 20, 21, are Sites of Ancient Habitations. 9, Burnt Stones on the clay. 10, A recent Indian Grave over two graves. 11, Portions of Three Skeletons in a pile. 12, 13, Skeletons in the clay. 14, Grave with Two Skeletons. 15, Grave with Skeleton, over which was an ash bed. 16, Pieces of a large Clay Pot. 17, Small Burial Mound. 18, Several small Excavations in the clay, filled with dark earth. 19, 24, See above. This Village Site was afterwards found to extend 200 feet east and south. 25, Burnt space under the dark soil extending to edge of large conical mound. 25, The Conical Mound, a monument over a single body. 27, 28, Cremation Places in the clay under the dark soil. 29, 30, 31, Very Ancient Graves deep in the clay. 32, Small Mound over four ancient graves in the clay.

Professor Frederic W. Putnam created the sketch map of the Serpent Mound in 1890. *From The Century Magazine.*

Investigators in the 1990s used radiocarbon dating on samples taken from the serpent's body to date construction around AD 1070, making the builders the Fort Ancient people, who built monumental animal effigies.[2] This was the prevailing opinion, at least until archaeologist William F. Romain led a project in 2010 that tested radiocarbon dates of several core samples within the mound. The project findings released in 2014 suggest that the effigy was constructed much earlier, about 321 BC, by the Adena people.[3] A possible explanation for the discrepancy with earlier radiocarbon findings could be that the Fort Ancient people refurbished the site, and the sample could have been from the soil that Putnam used to restore the mound. Regardless, there is no consensus among archaeologists.

The meaning of the effigy is also unclear. Squire and Davis saw a serpent devouring an egg, while archaeologist John P. MacLean, in 1884, interpreted the triangular section as a frog in the act of leaping away and depositing an egg down the serpent's throat.[4] In 1886, William Henry Holmes of the Smithsonian saw the effects of a semicircle around the western end of the oval, thus completing the eye of the serpent.[5] Romain once suggested that the effigy could be of a serpent devouring the sun, as in a solar eclipse, with the serpent representing the underworld and the sun, the upper world, as found in many Native American mythologies. With that interpretation, the Serpent Mound symbolizes "the eternal conflict between the opposite forces of light and dark, good and evil, life and death."[6]

The Serpent Mound is a site that inspires people to ponder the wonders of our past and drives archaeologists to keep searching for answers, just as Putnam did in 1883 when he wrote:

> *Reclining on one of the huge folds of this gigantic serpent, as the last rays of the sun, glancing from the distant hilltops, cast their long shadows over the valley, I mused on the probabilities of the past; and there seemed to come to me a picture as of a distant time, of a people with strange customs, and with it came the demand for an interpretation of this mystery. The unknown must become known!*[7]

For now, the secrets remain hidden.

2

WESTERN FRONTIER

During the time of the American Revolutionary War, the Ohio River Valley and Kentucky were America's western frontier. White settlers had started trickling into Kentucky around 1769. Among the first to cross the Cumberland Gap from Tennessee was the frontiersman Daniel Boone. North of the Ohio River was Indian territory occupied by Shawnee and Miami tribes, who crossed the river into the Kentucky lands during the winter to hunt buffalo. The Point, where the Licking River meets the Ohio River at present-day Covington, Kentucky, was a natural gateway between the territories. Hostility from the native peoples against intrusion into their hunting grounds kept white settlers scarce. When fighting in Massachusetts ignited the revolution on April 19, 1775, there were fewer than three hundred whites in Kentucky and none north of the Ohio River.

On March 14, 1775, land speculator Richard Henderson from North Carolina signed the Treaty of Watauga with representatives of Cherokee tribes. The pact granted Henderson's Transylvania Company the deed to seventeen million acres between the Kentucky, Cumberland, and Ohio Rivers, the majority of what would become Kentucky. Henderson, intending to establish a fourteenth colony, enlisted Boone to blaze a trail, the Wilderness Road, through the Cumberland Gap for prospective settlers. A few forts scattered throughout the territory were the first settlements. Boone was given charge of Fort Boonesborough along the Kentucky River, southeast of Lexington.

The Transylvania Purchase, though, was in violation of the Proclamation of 1763, in which the British government forbade any colonial settlement of lands west of the Appalachian Mountains. The proclamation was notoriously difficult to enforce and angered both settlers and Indian tribes. Eventually, the Transylvania Company's claims on the land were nullified. As far as the British were concerned, the land belonged to the Crown, anyway. The British claims to the land traced to the second charter of the Virginia colony in 1609. In addition to establishing the boundaries surrounding the first settlements, the charter granted an unfettered western boundary that extended "from sea to sea, west and northwest"[8] all the way to the Pacific Ocean—a bold claim, considering that much of that land had yet to be explored.

While the mighty British army chased George Washington all over the East Coast, the Kentucky settlers were more worried about Indian raiding parties recruited by the British. Fighting in Kentucky was "frontier warfare"—raids and hand-to-hand combat instead of pitched battles.[9] The threat to the white settlers was so great that, in 1776, two men were sent to petition the Virginia government for supplies to defend their forts.

George Rogers Clark, one of the delegates, was a twenty-three-year-old Virginian working as a deputy surveyor in Kentucky. His younger brother William would partner with Meriwether Lewis in 1804 on the Lewis and Clark Expedition. At Williamsburg, Clark asked the assembly for aid, but it treated the settlers as friends rather than fellow Virginians and offered only some gunpowder. Clark implied that they could go elsewhere for protection, possibly to the British, and told the assembly "if a country was not worth protecting it was not worth claiming."[10] The assembly relented, in effect recognizing Kentucky as part of Virginia. Clark argued that the Kentucky settlements were necessary for the protection of the Virginia frontier and successfully petitioned for the creation of Kentucky County in December 1776. In this way, Clark became one of the founders of the commonwealth.

Back in Kentucky, the legend of Daniel Boone was born. On July 14, 1776, a few days after the Declaration of Independence was approved, Shawnees abducted Boone's daughter Jemima Boone and sisters Betsy and Fanny Callaway from their canoe outside Boonesborough. Boone led a group of settlers that caught up to the Indians at camp near the Licking River. The girls were rescued and the Indians fled. News of the rescue spread, as did Boone's reputation, and the incident later inspired James Fenimore Cooper's novel *The Last of the Mohicans*.

In March 1777, Clark was commissioned as a major of the new Kentucky County. Boone and the fort leaders were made captains. Simon Kenton, a

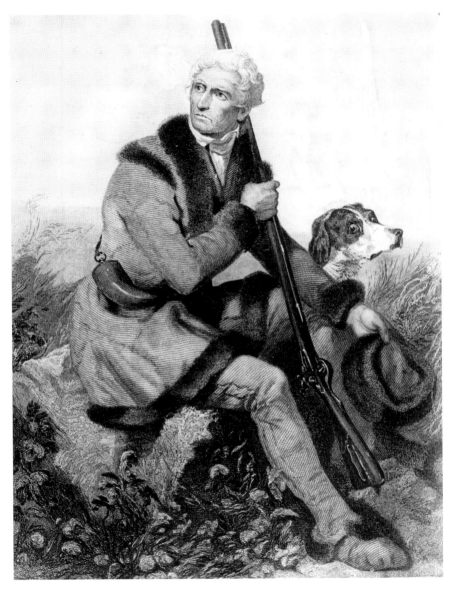

The reputation of Daniel Boone as a frontiersman was forged in the wilderness of Kentucky and the Northwest Territory. *Courtesy of the* Cincinnati Enquirer *archives.*

man equal in accomplishment to Clark and Boone, was enlisted as a spy to sneak into Indian lands. Kenton went by the name Simon Butler at the time, believing wrongly that he was wanted for murder (the man he fought still lived). Kenton proved his worth during an Indian attack on Boonesborough

on April 24, when a bullet struck Boone in the ankle. Kenton shot an Indian who had his tomahawk raised to scalp Boone and clubbed another attacker, then picked up Boone and carried him back to the fort. Boone, in typical understated fashion, thanked Kenton for saving his life: "Well, Simon, you have behaved like a man to-day; indeed you are a fine fellow."[11]

On February 7, 1778, Shawnee war chief Cottawamago, known to whites as Blackfish, captured Boone while he was collecting salt from a salt lick near the Licking River. Outnumbered, Boone agreed to convince the others in his party to surrender and spare an attack on the fort. The captured settlers were taken to the Shawnee village Old Chillicothe, near present-day Xenia, Ohio. Blackfish took a liking to Boone and adopted the frontiersman into the tribe as his own son. Boone's hair was plucked except for a scalp lock, and he was given the name Sheltowee, meaning Big Turtle. Boone was treated well during his time living with the Shawnee, but when he realized Blackfish planned to attack Boonesborough, Boone escaped on June 16 and traveled 160 miles in four days to warn the fort. He helped fortify the settlement so it was prepared for the attack on September 7.

Blackfish led more than four hundred attackers against sixty armed men, plus women and children, in the fort. The siege lasted nine days, yet only two whites and thirty-seven Shawnee were killed before the Indians quit. Boone, though, was charged with treason for surrendering to the Shawnee and pledging to side with the British. At his court-martial, Boone successfully defended himself, testifying that he had agreed to switch sides only as a ruse to spare lives and that he had warned them of the attack. Boone was acquitted.

As the highest-ranking officer in the West, Major Clark went on the offensive to end the Indian raids in 1778. Clark set up camp at the Falls of the Ohio, a settlement that became Louisville, and led two hundred men into the Illinois Country. He secured the villages of Kaskaskia, Cahokia and Vincennes with little or no resistance and made treaties with most of the Indian tribes in the area. The following year, Clark led a grueling march in the middle of winter across 180 miles of flooded land, sometimes in chest-high water, to recapture Vincennes, in what is now Indiana, without losing a man. The victory secured for the Americans what would be called the Northwest Territory.

The point at the mouth of the Licking River became a key gateway for confrontations in 1780. On April 12, Colonel William Lytle and his son, the future general William Lytle, were among a group of settlers traveling down the Ohio River who faced off against an encampment of Indians where

Front Street would later intersect Broadway in Cincinnati.[12] The outnumbered Indians fled, and the settlers moved on; the Lytles would return and become a prominent Cincinnati family.

That spring, Captain Henry Bird led British troops and Indians across the point into Kentucky and captured two American forts. Indians murdered Captain Richard Callaway, whose daughters had been abducted with Jemima Boone. In retaliation for these attacks, Clark amassed a thousand men, including Boone and Kenton, for a campaign to punish the Shawnee. Clark marched to the Point and crossed the Ohio River to the future site of Cincinnati on August 1, 1780. Abraham Thomas recalled the moment in the *Troy Times* in 1839:

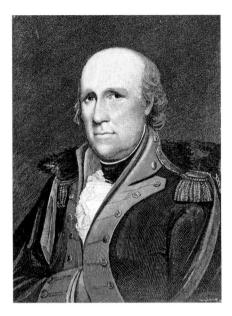

George Rogers Clark led successful campaigns that secured the Northwest Territory during the Revolutionary War and set up the first building on the future site of Cincinnati. *Courtesy of the* Cincinnati Enquirer *archives.*

> *In descending the Ohio Daniel Boone and myself acted as spies on the Kentucky side of the river, and a large party, on the Indian side, was on the same duty; the latter were surprised by the Indians, and several killed and wounded….Before the boats crossed over to the Indian side Boone and myself were taken into the foremost boat and landed above a small cut in the bank, opposite the mouth of Licking. We were desired to spy through the woods for Indian signs. I was much younger than Boone, ran up the bank in great glee, and cut into a beech tree with my tomahawk, which I verily believe was the first tree cut into by a white man on the present site of Cincinnati.*[13]

At the site "the forest everywhere was thick set with heavy beech and scattering underbrush of spice-wood and pawpaw."[14] Here, Clark's men cut timber to erect a stockade as an advance base. The structure, "a little place stockaded in, saplin[g]s ten feet long set on end,"[15] was the first built in Cincinnati.

The next day Clark and his men headed north to Old Chillicothe. Finding it abandoned, Clark burned the village and cornfields and continued to Piqua (aka Pickaway), near present-day Springfield, and rousted the Shawnees there. It was the only significant engagement in Ohio during the war.

Although the British surrender at Yorktown on October 19, 1781, effectively ended the Revolutionary War, the treaty was not signed for another two years, and in the West, skirmishes continued between the Indians and Kentucky settlers. In August 1782, Indians and British Loyalists ambushed and routed Boone and the Kentucky militia at Blue Licks on the Licking River, in what is now Robinson County, Kentucky. Though the defeat had no real impact on the Revolution, the Battle of Blue Licks was the last major engagement in the war and triggered another retaliatory campaign from Clark, now a brigadier general, against the Shawnee villages.

In early November, Clark again took one thousand men with Boone and Kenton across the river at the future Cincinnati site and marched to Piqua, but they found the village deserted and the Indians unwilling to fight. Captain William McCracken, who had been lured into an ambush and shot, died on the return trip as they descended the hills into the Cincinnati basin. He was buried in the blockhouse Clark had built near where Main Street would later approach the river; they then burned the log house.[16] Clark and the troops agreed to meet at the spot, or possibly across the river in Kentucky, exactly fifty years later to the day. In November 1832, only a handful of the survivors planned to make that meeting. Clark and Boone had died; Kenton was one of fifteen to attempt the trip. But a cholera outbreak swept through Cincinnati, and the reunion was canceled.[17]

The first biography of Daniel Boone appeared shortly after the war, in 1784, as an appendix of *The Discovery, Settlement and Present State of Kentucke* by John Filson. The narrative—purported to be "The Adventures of Col. Daniel Boon" in Boone's own words, though written by Filson—was an unabashed advertisement for the western frontier, where Filson was invested in settlements. He was a partner, along with Matthias Denman and Colonel Robert Patterson, in founding a settlement opposite the Licking River. Filson was the surveyor for the site, which he named Losantiville by cobbling together syllables from different languages to mean "city opposite the Licking River." Around October 1, 1788, Filson disappeared while exploring the Miami woods and was never seen again. It was presumed that he was killed by Indians. Israel Ludlow took over his shares and served as the new surveyor when Losantiville was founded on December 28 of that year. The name was changed to Cincinnati twelve months later.

3

THE HEARTY BOYS OF AMERICA

History has not been kind to the graves of the soldiers of the American Revolution. Untold numbers of veterans who fought to secure this country's independence lie in unmarked graves. Some have been lost entirely.

After the war, many soldiers were given bounty land grants in exchange for their service in the Continental Army or militia, and they headed westward into the territories beyond the thirteen original colonies. When the Patriots died, they were buried in remote rural spots or urban graveyards close to town. Sanitarians in those days believed the miasma theory: vapors or "bad air" from decaying corpses were a cause of illness. As a result, many of those graveyards were covered over; some graves were relocated to idyllic suburban cemeteries.[18] Others were left underground and buildings, like Cincinnati's Music Hall, were erected above them. Burial records of that period are so poor that the identities of remains will probably never be known.

Thanks to efforts of the Daughters of the Revolution and the Sons of the Revolution, forty-five Patriots of the War of Independence have been identified as buried in Spring Grove Cemetery, with another ten listed in memoriam, though their graves have been lost. One of those lost graves was for Joshua Wyeth, a participant in the Boston Tea Party, a volunteer at the Battle of Bunker Hill and a soldier in the Continental army. Diligent work by Wyeth's family, though, has made sure he will not be forgotten.

Tina Wyeth Baker and her brother Jeff Wyeth extensively researched the family genealogy, but they could find no grave for Joshua, the brother

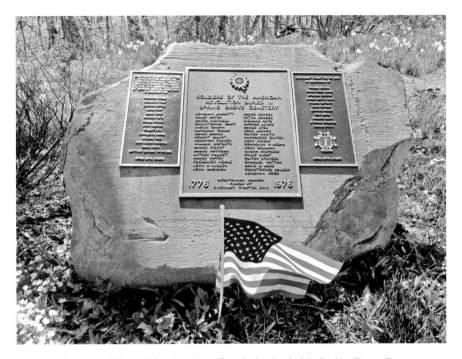

A marker lists the soldiers of the American Revolution buried in Spring Grove Cemetery, including some Patriots, like Joshua Wyeth, in memorial because their remains have been lost. *Courtesy of Jeff Suess.*

of their fourth great-grandfather, despite his service in the founding of the nation.

Joshua Wyeth was born on October 6, 1758, in Cambridge, Massachusetts. In 1820, while living in Springfield, Ohio, he testified to his military service in the Revolutionary War for his pension application. At age fifteen, he was working as an apprentice blacksmith when he joined the mob on December 16, 1773, and threw the East India Company's tea overboard into Boston Harbor as a protest against British tyranny and taxation. The men swore an oath of secrecy so the British could not identify them and retaliate. When conflict erupted with the British, Wyeth volunteered at the Battle of Bunker Hill on June 17, 1775. He then enlisted in the Continental army and served as a private in Captain Eliphalet Newell's company, the first regiment of the Massachusetts Line under Colonel Henry Knox, and then as a blacksmith in the Corps of Artificers. He participated in the battles of Long Island at Flatbush, Harlem Heights and White Plains in 1776. In his later years, Wyeth lived in Springfield and then Cincinnati.

It was in Cincinnati that Wyeth finally opened up about his involvement in the Boston Tea Party. In fact, Wyeth himself may have been responsible for popularizing the phrase "Boston Tea Party." A widely circulated newspaper account in 1826 mentioned "a temperate, hardy old veteran" in Cincinnati who "often boasts of the 'Boston Tea Party,'"[19] referring to the party of men, not the event, which until then had been called "the destruction of tea in Boston Harbor." This was near the country's fiftieth anniversary, and there was renewed interest in the revolution. In the July 1827 edition of *Western Monthly Review,* published in Cincinnati, editor Timothy Flint carried an account by Wyeth of his involvement in the Boston Tea Party, "nearly in his own words."[20] It was the first circulated first-person account by a participant to be published, over fifty-three years after the historic event. Here are excerpts:

> *Our numbers were between twenty-eight and thirty. Of my associates, I only remember the names of Frothingham, Mead, Martin and Grant. We were met together one evening, talking over the tyranny of the British government, such as the heavy duties, shutting up the port of Boston, the murdering of Mr. Gray's family,*[21] *sending people to England for trial, and*

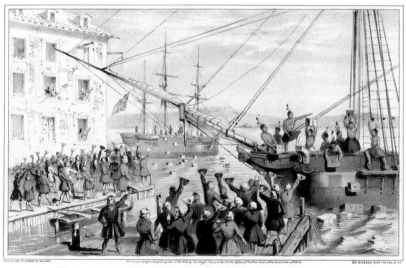

THE DESTRUCTION OF TEA AT BOSTON HARBOR.

The term "Boston Tea Party" wasn't used until stories of Joshua Wyeth's account circulated in 1826. Before that, it was known as "the destruction of tea at Boston Harbor," as in this 1846 lithograph. *Courtesy of the Library of Congress/Sarony & Major.*

sundry other acts of oppression. Our indignation was increased by having heard of the arrival of the tea-ships at this time. We agreed, that if the tea was landed, the people could not stand the temptation, and would certainly buy it. We came to a sudden determination, to make sure work of it, by throwing it all overboard.…We agreed, in order, as much as we might, to prevent ourselves from being discovered, to wear ragged clothes, and disfigure ourselves as much as possible. We concluded to meet at an old building at the head of the wharf, and to fall in one after another, as if by accident, so as not to excite suspicion. After having pledged our honor, that we would not reveal our secret, we separated.

At the appointed time, we all met according to agreement. We were dressed to resemble Indians, as much as possible. We had smeared our faces with grease, and soot, or lampblack. We should not have known each other, except by our voices, and we surely resembled devils from the bottomless pit, rather than men.…We boarded the ship which was moored by the wharf.…Some of our number jumped into the hold, and passed the chests to the tackle. As they were hoisted on deck, others knocked them open with axes, and others raised them to the railing, and discharged their contents overboard.

We stirred briskly in the business, from the moment we left our dressing room. We were merry in an under tone, at the idea of making so large a cup of tea for the fishes, but were as still, as the nature of the case would admit. No more words were used, than what were absolutely necessary. Our most intimate acquaintances, among the spectators, had not the least knowledge of us. I never labored harder in my life; and we were so expeditious, that, although it was late in the evening, when we began, we had discharged the whole three cargoes before morning dawn.

It may be supposed, that there was much talk about this business next morning. The tories, civil, military and spies, made a great fuss, and called the business divers hard names. Proclamations and rewards, to procure detection, were all to no purpose. We pretended to be as zealous, to find out the perpetrators, as the rest. We often talked with the tories about it. We were all so close and loyal, that the whole affair remained in Egyptian darkness. We used, sometimes, afterwards, to meet and talk the affair over, never failing to end, by drinking—"the hearty boys of America for ever!"[22]

The *Boston Gazette* challenged the accuracy of Wyeth's account,[23] claiming he was probably just a spectator, but his errors are relatively minor. For instance, Wyeth said the ships were in Hancock's wharf, but it was Griffin's

The picturesque Washington Park, across from Music Hall, was built atop the Twelfth Street burying grounds where Joshua Wyeth was likely buried. *Courtesy of the* Cincinnati Commercial Tribune.

wharf. Wyeth hadn't been in Boston in decades, so is it likely he was confused. But Wyeth was correct about who else was with the party; the first list of participants in the Boston Tea Party, not published until 1835, included Nathaniel Frothingham, John Martin, Moses Grant and a "Mr. Wyeth."[24]

French artist Auguste Hervieu depicted Wyeth in the crowd in his painting of the Marquis de Lafayette's landing at Cincinnati in May 1825, along with prominent local citizens William Henry Harrison, William Lytle, Daniel Drake, Jacob Burnet, Flint and Hiram Powers—whether they were present at the event or not.[25] The painting has been lost, probably in Europe.

Wyeth died on January 22, 1829,[26] with a funeral at his home on Longworth Street (a street on the west side of downtown between Fifth and Sixth Streets that was wiped out by Interstate 75). There is no record of his burial. So Tina Wyeth Baker sought help from Christopher Smith, reference librarian at the Public Library of Cincinnati and Hamilton County, who determined that Wyeth was probably buried at the Episcopal and Presbyterian burying

grounds on Twelfth Street in Over-the-Rhine, though there are no known burial records of the site.

In 1855, the city bought the grounds to convert them into Washington Park. Notices were placed in newspapers calling for families to pay to move their loved ones to the Wesleyan or Spring Grove Cemeteries, but most, like Wyeth, had no family nearby and were not moved. The remaining stones were laid on the ground and three feet of dirt was poured over the graves. When Washington Park was renovated in 2010, crews uncovered dozens of graves. Three found tombstones were erected in the park as symbolic of the past graveyard, and the discovered remains were moved to Spring Grove. Those bodies left undisturbed were covered over and forgotten. Wyeth's grave is probably still under an undisturbed portion of the park opposite the south wing of Music Hall. Armed with this knowledge, in 2014 Baker was able to get approval from the U.S. Department of Veterans Affairs for a memorial tombstone for Wyeth. It was placed in Spring Grove, where his remains should have been reburied.

"There are many monuments to honor the leaders of our drive for independence," Baker wrote, "but for the ones who did the grunt work, they are lucky if a stone in a cemetery still marks their contribution. At the very least, all veterans deserve a memorial marker for their grave."[27]

The hearty boys of America forever!

4

MEDICAL PIONEERS

C incinnati can lay claim to pioneers of medicine, such as Dr. Albert B. Sabin at Children's Hospital Research Foundation, who developed the oral live virus polio vaccine that helped eradicate polio. There were also pioneers in the other sense, in the days when Cincinnati was still on the frontier.

DR. DANIEL DRAKE

Dr. Daniel Drake was the foremost physician in what was the West's largest city in the first half of the nineteenth century and was once the most famous man in Cincinnati. For the breadth of Drake's accomplishments, historian W.H. Venable likened him to Benjamin Franklin: "So many good works did he undertake, so much did he accomplish…that I think he may be called with propriety the *Franklin of Cincinnati*."[28] Today, his name adorns the Daniel Drake Center in Hartwell, but as early as 1909, biographer Otto Juettner felt that Drake was "entirely forgotten."[29]

Drake was born on October 20, 1785, in Essex County, New Jersey. When he was two, his family moved to Mays Lick, Kentucky, which at the time was still Indian country. His parents were poor and barely literate, but Drake aspired for more. He befriended Dr. William Goforth, who inspired him to become a doctor, and moved to Cincinnati in 1800 to apprentice under

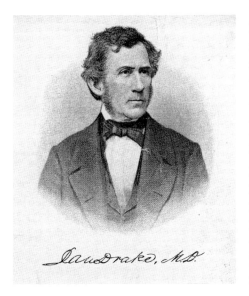

Dr. Daniel Drake, the most celebrated physician in Cincinnati's early days, was also a scientist and founded the Medical College of Ohio. *Courtesy of the* Cincinnati Enquirer *archives.*

him, even though Goforth had no medical degree. Medical training in America at that time followed the preceptorship plan, an arrangement in which a student apprenticed under an established physician for about four years until he had accumulated enough knowledge to be called a doctor. Nonetheless, in 1805, Drake left to attend the University of Pennsylvania to study under the preeminent physician Benjamin Rush and eventually earned his medical degree. Drake returned to Cincinnati and quickly built a reputation as a laudable physician, scientist, writer and visionary.

His most noted achievement was the founding of the Medical College of Ohio in 1819, the second medical school west of the Alleghany Mountains. It merged with the University of Cincinnati in 1896 and is now the UC College of Medicine. Drake also started and ran the Medical Department of Cincinnati College from 1835 to 1839, and he served many years on the faculty at Transylvania University in Lexington, Kentucky, and the Louisville Medical Institute. In 1821, he petitioned for the creation of Commercial Hospital and Lunatic Asylum, the nation's first teaching hospital, at Twelfth Street and Central Avenue. The hospital became Cincinnati Hospital and in 1915 was replaced by Cincinnati General Hospital, now known as University Hospital.

Drake's interests and influence were varied. He wrote essays on medicine, medical education and forest preservation. He authored several books on the early days of Cincinnati, noting as well the region's weather and geology. His book *Natural and Statistical View, or Picture of Cincinnati* (1815) gave him a national reputation. He suggested routes for a canal system that eventually became the Miami & Erie Canal, and he was an early proponent for a railroad to the east. In 1818, he helped create the Western Museum, a repository of scientific artifacts to which he donated his extensive collection of minerals, mammoth bones and antiquities. Drake hired artist John James Audubon

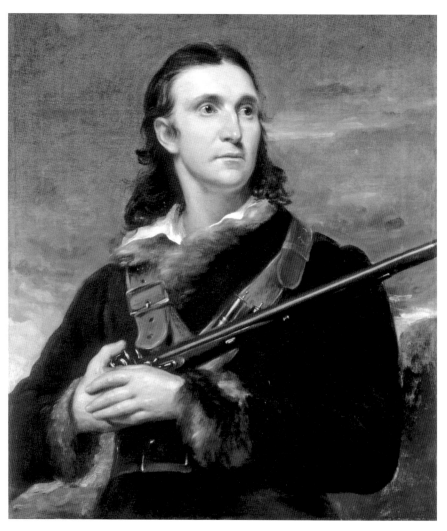

Naturalist painter John James Audubon was the first taxidermist hired for Daniel Drake's Western Museum. *Courtesy of the White House Historical Association/John Syme.*

as the museum's taxidermist and to set up exhibits. Recognizing his talent, Drake arranged for a display of Audubon's bird drawings and suggested that Audubon continue the work of Alexander Wilson's ornithology portraits for the western region, advice the wildlife artist took to heart to create his seminal *Birds of America*. As a result of Drake's 1833 speech extolling the virtues of the buckeye tree and his proposal for it as the state emblem, Ohio became the Buckeye State.

"In many ways Daniel Drake is the most unique figure in the history of American medicine," wrote Sir William Osler of Johns Hopkins University. "He literally made Cincinnati....He founded nearly everything that is old and good in that city."[30]

Drake died on November 5, 1852, and is buried in Spring Grove Cemetery. Dr. John Shaw Billings, an 1860 graduate of the Medical College of Ohio who as surgeon general built up the National Library of Medicine, admired Drake "as a man whose fame, as compared with that of his contemporaries, will probably be greater a century hence than it is today, and whose name... should be among the first of the illustrious dead of the medical profession in the United States."[31]

"THE FIRST CAESARIAN SECTION IN AMERICA"

Dr. John Lambert Richmond followed Drake's path from humble beginnings to frontier medicine; appropriately, he studied under Drake. Richmond's place in the annals of medicine was secured on a stormy night in 1827, when he performed a harrowing backwoods Caesarian section, the first to be recorded in America.

Richmond was born on April 5, 1785, near Chesterfield, Massachusetts, and grew up in western New York. With just two weeks of formal schooling, Richmond was self-taught and well learned. He studied Latin and Greek from lessons pinned to his sleeves while he worked. He toiled away in fields or down in coal mines to support his wife and ten children. Seeking opportunities westward, the family settled in Cincinnati in 1817. Richmond found a job as a janitor in the building that housed Drake's Medical College of Ohio; he boldly asked Drake to allow him to attend the lectures in exchange for half his meager wages. In 1822, Richmond was in the second class to graduate from the medical college, making him one of the few accredited doctors in the West. He settled in Newtown, a village ten miles east of downtown Cincinnati, where he served as both the town doctor and a Baptist minister for a church on Clough Road.

On Sunday, April 22, 1827, Richmond was summoned from the church to attend to Miss E.C., a free black woman across the Little Miami River who was suffering convulsions through a difficult labor. A storm was raging, and the doctor had to row a skiff across the swollen river to reach her, seven miles away. A few years later, Richmond reported the dramatic events of

that night in Drake's *Western Journal of Medical and Physical Sciences*. He found that the patient had been in labor for thirty hours. He gave her laudanum and sulphuric ether for her convulsions and put a flannel soaked in hot spirits to her feet. It is worth noting that the use of sulphuric ether as anesthetic was not announced for another two decades.[32] As Richmond described the conditions, the log cabin was newly constructed and the crevices had not yet been chinked. There was no floor but the dirt. Midwives held up blankets to block the wind from blowing out the lone candle. The patient was in severe pain. With no help coming and little medicine available, Richmond determined that she would die if he did not operate.

"Feeling a deep and solemn sense of my responsibility," he wrote, "with only a case of common pocket instruments, about one o'clock at night, I commenced the Caesarean section." He had only read about the risky procedure. There was no antiseptic or known anesthesia in those days. He made incisions in the abdomen and uterus and detached the placenta. The "uncommonly large" child could not be extracted. Believing the baby had perished and "that a childless mother, was better than a motherless child," he cut the fetus to remove it.[33] Following medical practice at the time, he sutured all but the lower two inches of the woman's incision, which he closed a few days later. He reported that she recovered and started working again in twenty-four days. She later married but had no children.

Richmond's article was the first to record a Caesarian section in America. A few earlier cases have been reported, most notably of Dr. Jesse Bennett of Mason County, Virginia (now in West Virginia), who is said to have successfully operated on his wife, Elizabeth Bennett, on January 14, 1794. But many medical

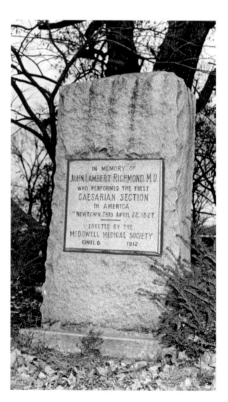

The John Lambert Richmond monument stands in Newtown, Ohio, to honor his historic operation. *Courtesy of the* Cincinnati Enquirer/*Allan Kain.*

historians, including Juettner,[34] question the accuracy of the Bennett claim, noting that the only evidence of the operation was an essay by a friend of Dr. Bennett, published nearly a century afterward in 1892.[35] In 1912, the McDowell Medical Society of Cincinnati erected a five-foot-tall granite monument on Church Street in Newtown honoring Dr. Richmond and "the first Caesarian section in America." Today, about one-third of births in America are by C-section.[36]

A cholera epidemic, apparently brought over by European immigrants, hit the United States in 1832. In Cincinnati, Richmond and Dr. Jesse Smith, the professor of anatomy and surgery at the medical college, led the city's emergency medical service. The disease struck both doctors, but only Richmond recovered. In gratitude to the doctors, the city named Richmond Street and Smith Street in the West End. After the cholera epidemic, Richmond moved to Indiana, where he died on October 12, 1855.

5

A VISIT TO HELL

The Western Museum, as envisioned by Dr. Daniel Drake and the Western Museum Society in 1818, was to be a collection of scientific materials—prehistoric bones, mineral samples, Indian artifacts and wildlife specimens—to educate the city's inhabitants on the natural history of the region they were settling. John James Audubon was hired as a taxidermist and to design displays, set up in the new Cincinnati College building where the Mercantile Library building is today. The Western Museum opened on June 10, 1820, but the Panic of 1819 hit Cincinnati particularly hard and affected the society's ability to support the institution or to pay Audubon, who shortly left to pursue his career as a wildlife artist. By 1823, the society handed the Western Museum over to Joseph Dorfeuille, a natural scientist and contributor, with the stipulation that the families of the founders still be allowed free admission.

Dorfeuille was faced with the same financial situation, and initial public interest waned. To attract more patrons, he lowered the scientific standards of the museum, allowing exhibits of dubious authenticity and, eventually, outright fabrications, such as a monkey's head and hands stitched to a fish and passed off as a mermaid specimen. Dorfeuille had competition from Letton's Museum, started by Ralph Letton in 1819 at Fourth and Main Streets. The city of ten thousand, though the fastest growing in the West, struggled to support two museums. It is no wonder both institutions resorted to creative methods of attracting attention.

Then along came an Englishwoman with unconventional ideas. Frances "Fanny" Trollope arrived in Cincinnati on February 10, 1828, having

Frances Trollope had greater success with her idea for "Infernal Regions" than her infamous Trollope's Bazaar, though she never took credit for the museum display. *From Domestic Manners of the Americans.*

heard of the city's growing reputation for culture, and hoped to reverse the family's financial woes. Accompanying Trollope and her children (her son, novelist Anthony Trollope, was not with them) was French painter Auguste Hervieu, who would contribute to her artistic plans. Trollop famously built an outrageous marketplace known as Trollope's Bazaar on the south side of Third Street between Ludlow and Broadway Streets. The bazaar was constructed of myriad styles, from Egyptian to Moorish—incongruous

with the Neoclassical brick neighborhood—and featured a coffeehouse and live entertainment, all of which may have been too obtuse in 1829 for a frontier city whose aspirations of high culture exceeded reality. The townsfolk dubbed the bazaar "Mrs. Trollope's Folly"; it failed after a few months. Trollope got her revenge after returning to England. In 1832 she published *Domestic Manners of the Americans*, a scathing account of her travels. She targeted Cincinnati as ill mannered and unsanitary, which may have been apt for a city replete with slaughterhouses and nicknamed Porkopolis.

Trollope may have been emboldened to attempt her bazaar in Cincinnati by the people's earlier response to her ideas. Trollope took an interest in the Western Museum, then located at the corner of Main and Columbia (Second) Streets, likely for its similarities to the Egyptian Hall in London's Piccadilly, built in 1812 by William Bullock, a friend who lived across the Ohio River and planned a European-style utopian community named Hygeia at what is now Ludlow, Kentucky. Bullock's influence on Trollope's plans is evident, but it should be noted that his Hygeia also proved fruitless.

In April 1828, a couple of months after arriving in the city, Trollope suggested to Dorfeuille a dramatic attraction known as the "Invisible Girl." A chamber inside the Western Museum was adorned with specters and witches engaged in magic rites, as depicted by wax figures or on transparencies painted by Hervieu. Parties of no more than twelve would brave to enter the chamber and ask of the Oracle three questions, receiving responses from the invisible girl via a voice sounded through a horn. The "invisible girl" was Trollope's son, Henry, who put his classics studies and knowledge of Latin, Greek and French to good use in answering patrons' questions. The theatrical exhibit was a hit for its eight-week run, but that was just a teaser for Trollope's sensational follow-up.

The museum's wax figures were made by sculptor Hiram Powers at the beginning of his career. Under the patronage of Nicholas Longworth, Powers would move to Florence, Italy, in 1837 as one of the most respected American talents in Europe. His statue *The Greek Slave*, the first fully nude female statue to be shown in America, toured the nation in the 1840s. The statue was so provocative that many exhibitors required male and female patrons to view it separately, and it caused great controversy when it was shown at the Apollo Hall in Cincinnati in 1848–49. Back in 1828, Powers was a young artist whom Hervieu tried to take under his wing.

Trollope's idea following the "Invisible Girl" was to create an exhibit of the striking scenes from Dante's epic poem, *The Divine Comedy*. The idea "fired the imagination of Powers,"[37] who conjured terrifying wax figures

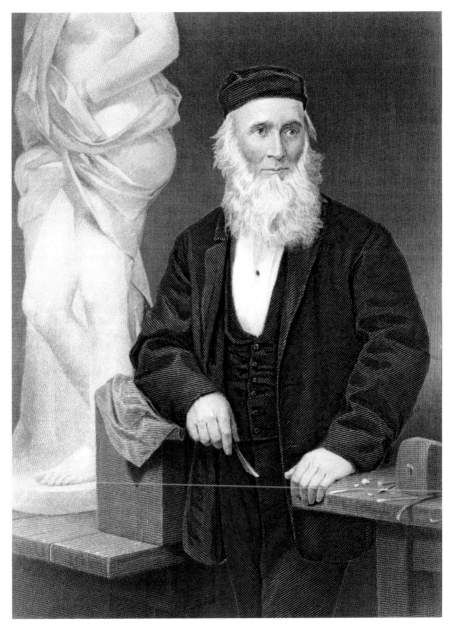

Hiram Powers, who built the moveable figures of "Infernal Regions," went on to acclaim as the sculptor of *The Greek Slave. Courtesy of the Library of Congress/Alonzo Chappel.*

and a hellish landscape of fire and ice. The attraction, called "Infernal Regions," opened on July 4, 1828. Hervieu had painted transparencies showcasing Purgatory and Paradise, but it was Powers's Inferno that people came to see.

After paying twenty-five cents, patrons climbed stairs to the museum's second floor, where they found a twenty- by twelve-foot chamber out of a nightmare. The scene was placed behind iron bars, adding a sense of danger that it had to be contained. Powers explained, "Behind a grating I made certain dark grottoes, full of stalactites and stalagmites, with shadowy ghosts and pitch-forked figures, all calculated to work on the easily-excited imaginations of a Western audience."[38] The central wax figure was of Minos, the judge of hell, sitting on a "throne of darkness" and dressed in a sable robe that revealed his horns, cloven foot and barbed tail. One hand carried a pitchfork; the other pointed to an inscription: "Whoever enters here leaves hope behind!" On the devil's right was a frozen lake with the heads of condemned souls in the throes of suffering, surrounded by hideous imps. To his left, a skeleton ascended an icicle staircase amid hellfire pouring from its sockets. Discordant, unearthly voices and groans emanated from the room below.[39]

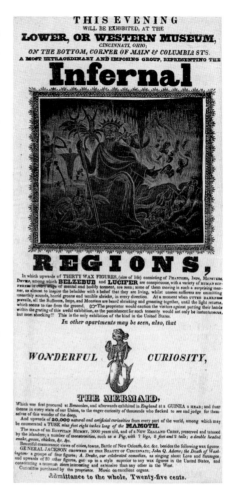

A rare broadsheet, believed to be by Hiram Powers, advertises the "Infernal Regions" display at the Western Museum. *Courtesy of Cincinnati Museum Center—Cincinnati History Library and Archives.*

Thinking that motion would add reality to the scene, Powers went among the figures "dressed like the Evil One, in a dark robe, with a death's head and cross-bones wrought upon it, and with a lobster's claw for a nose."[40] He rigged wires connecting an electrical machine to the bars, and from a wand

in his hand "could discharge quite a serious shock upon anybody venturing too near the grating."[41] This worked doubly to discourage patrons from touching the exhibit and to persuade them from a life of sin. Tiring of the performance, Powers invented a series of automata to have the figures move by strings, creating the 1820s version of animatronics.

"In short, wax, paint and springs have done wonders," Trollope wrote in *Domestic Manners*. Strangely, she made no mention of her own contributions and instead credited "Infernal Regions" to Dorfeuille's "fertile fancy": "Terror, astonishment, curiosity, are all set in action, and all contribute to make 'Dorfeuille's Hell' one of the most amusing exhibitions imaginable."[42]

"Infernal Regions" was a tremendous success that would last in some form for nearly forty years. Dorfeuille sold the museum and exhibits in 1839 and took "Infernal Regions" to the City Saloon museum at 218 Broadway in New York City, but Dorfeuille died the next year and it is unknown what became of the wax figures. They were possibly acquired by Scudder's American Museum next door, which was purchased by P.T. Barnum in 1841. Barnum's American Museum burned down in a spectacular fire on July 13, 1865. A version of "Infernal Regions" remained at the Western Museum for years, and a rival exhibit opened at Frederick Frank's museum on Front Street, but that burned down on March 31, 1840. There is some debate about which museum had the original figures made by Powers, but a friend's letter to Powers indicates Dorfeuille took them to New York.[43] The Western Museum later moved to Main and Pearl Streets, then finally to 78 Sycamore Street at the northeast corner with Third Street, under a succession of owners. What remained constant were "Infernal Regions" and the museum's reputation for hokum. Any vestigial scientific value was wiped away by grotesque displays such as the head and hand of executed killer Mathias Hoover preserved in jars. In 1861, humorist Artemus Ward, after attending a show at the new Pike's Opera House, paid a visit to the tattered museum and still delighted in the pantomime of "Infernal Regions," calling it "the best show in Cincinnati."[44] The Western Museum closed in 1867, and the contents were sold at auction.

Although its reputation was overrun by crowd-pleasing curiosities and charlatanism, the Western Museum's scientific legacy remains to this day. The original specimens are long gone, but the collections begun by Drake and Audubon are part of the Cincinnati Museum of Natural History, located in the Cincinnati Museum Center at Union Terminal.[45]

6

MARY JANE'S JOURNAL

One day in the early 1990s, Bonnie Speeg was browsing through the local history section in Duttenhofer's Books, a used bookstore in Clifton Heights, and came upon a handwritten, cotton-rag journal by "Miss Mary Jane Irwin" from 1843. For a collector of handwritten letters, especially by women, this was a treasure. The journal was a composition assignment for the Cincinnati Institute for Young Ladies at Fourth and Vine Streets, where the young Ms. Irwin attended. Beginning on January 1 of that year, Mary Jane wrote of her daily experiences and ended up chronicling life in the early days of the Queen City.

Speeg then spent years delving into Mary Jane's history, digging through newspaper files, city directories, censuses, burial records and family papers. "Researching the journal was a huge history lesson of Cincinnati," Speeg said.[46] She wasn't kidding.

Mary Jane, who was fourteen years old when she wrote the journal, lived with her parents in a house at Ludlow Street between Fourth and Arch Streets, where the old Guilford Public School building stands today near Lytle Park on the east side of downtown. On that spot, in 1789, when the newborn city was still called Losantiville, Fort Washington was set up to protect the Northwest Territory from Indian raids. The fort was dismantled in 1808, and early settlers, including Dr. Daniel Drake, built their homes there. The Fort Washington monument on Ludlow is at the approximate location of the Irwins' front door.

Mary Jane was born on March 21, 1829, the eldest daughter of Archibald and Emily Irwin from Pennsylvania. Archibald came to Cincinnati in the

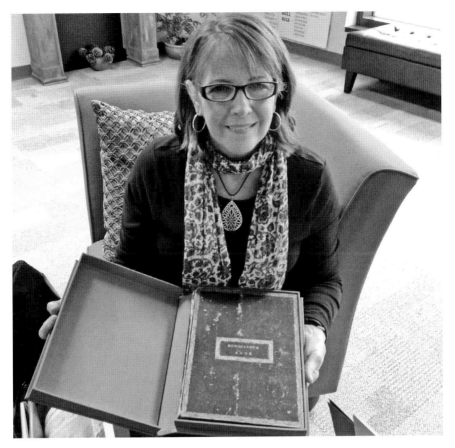

Bonnie Speeg found Mary Jane Irwin's journal in a used bookstore and then discovered its incredible links to Cincinnati history. *Courtesy of the* Cincinnati Enquirer/*Jeff Suess.*

1820s, working as a steamboat commission merchant, something of a family business, and later was treasurer for the Little Miami Railroad.

Archibald Irwin Jr., first cousin to Mary Jane's father, lived a few doors down at Broadway and Arch Street. He started Irwin & Foster, a steamboat agency and commission business at 4 Cassilly's Row at Front Street near Broadway, with Dunning Foster, the elder brother of the great American songwriter Stephen Foster. Stephen himself worked as a bookkeeper for his brother's company in 1846, boarding at Jane Griffin's house on the south side of Fourth Street, east of Broadway, on the same block as Mary Jane. Foster wrote his first hit, "Oh! Susanna," during his time living in Cincinnati.

Mary Jane's "Aunt Jane" mentioned in the journal is believed to be Jane Irwin Harrison, an Irwin cousin and the daughter-in-law of President

William Henry Harrison,[47] who lived in North Bend, about fifteen miles west of Cincinnati. Two years before Mary Jane recorded her journal, Harrison had been the first Whig candidate elected president and headed to Washington, D.C., early in 1841. First Lady Anna Harrison stayed behind in North Bend, intending to join her husband in the spring when the weather was better, so Jane Harrison, the widow of William Henry Harrison Jr., accompanied the president-elect to his inauguration. President Harrison died while in office just a month later, having served the shortest presidential term in history. The First Lady never made it to Washington; instead, Jane Harrison had acted as the official White House hostess during the brief presidency. Jane's sister, Elizabeth Ramsey Irwin, was married to another of the president's sons, John Scott Harrison, and was the mother of Benjamin Harrison, the twenty-third president.

In her journal, Mary Jane wrote of dance lessons at the Trollope's Bazaar building and reading *Nicholas Nickleby*, a year after Charles Dickens paid the Queen City a visit. Among her neighbors were Nicholas Longworth, living in the house on Pike Street that is now the Taft Museum, and the Lytle family in a mansion on Lawrence Street.

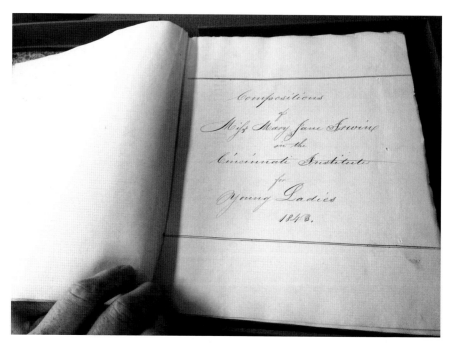

The title page of Mary Jane's journal shows her fine handwriting. The journal was written as an assignment for the Cincinnati Institute for Young Ladies in 1843. *Courtesy of the Cincinnati Enquirer/Jeff Suess.*

March 21: This is my fourteenth birthday. William Henry Harrison spent the evening at our house. [Not the president, who died in office two years earlier, but likely his grandson, the son of "Aunt Jane."] *We…amused ourselves by playing button, lawyer and Geographical cards and battledore* [similar to badminton].

May 19: Josie and Lizzie Lytle [sisters of future Civil War Brigadier General William Haines Lytle] *came over and we tried to have an opera…a parcel of girls mumbling and singing….It sounded like the screech owl's song or the black man's banjo.*[48]

"She's just a real smart aleck of a girl," Speeg said.[49] In one recorded incident, Mary Jane threw a glass of ale in her girlfriend's face for violating temperance.

One of Mary Jane's last entries tells of walking with former president John Quincy Adams, then seventy-six years old, to lay the cornerstone for Ormsby McKnight Mitchel's observatory on the peak of Mount Ida.

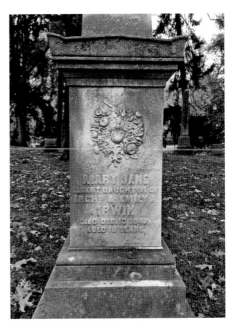

November 9: The procession formed at 10 o'clock to escort John Quincy Adams to the hill to lay the cornerstone of the observatory, but as the weather was very unpleasant he did not deliver his speech.… John Quincy Adams was to speak at the Baptist Church. Father waited and went with us. The people on each side of the street, and Mr. Adams…walked through the middle preceded by a band of music. We could not go into the Church as it was very crowded.[50]

The speech was instead given the next day at Wesley Chapel on Fifth Street between Broadway and Sycamore. Reportedly, this was the last speech Adams gave in public. After his visit, Mount

Mary Jane Irwin died at age eighteen and is buried in Spring Grove Cemetery, surrounded by the graves of her family. *Courtesy of the Cincinnati Enquirer/Jeff Suess.*

Ida was renamed Mount Adams in his honor. The observatory, along with the cornerstone, was moved to its present location in Mount Lookout in 1873. The original building on St. Paul Place was converted into Holy Cross Monastery; it was torn down in 1899. Artist Tina Westerkamp used a portion of Mary Jane's fine penmanship to illustrate Cincinnati Observatory founder Mitchel for an ArtWorks mural in Mount Adams.

Mary Jane died of consumption on December 13, 1847, at the age of eighteen. She was one of the first buried in Spring Grove Cemetery, established in 1845, and is surrounded by her family.

PART II

THE CIVIL WAR

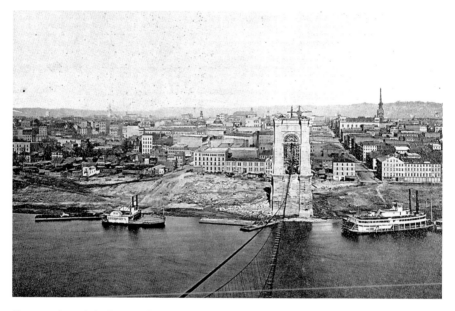

Construction of the John A. Roebling Suspension Bridge was halted by the Civil War. It was completed in 1866. *Courtesy of the* Cincinnati Enquirer *archives.*

7

Salmon P. Chase

Salmon P. Chase is perhaps the most accomplished Cincinnatian not named Neil Armstrong. Yet he is little known in the city where he rose to prominence. Historians have paid less attention to Chase among the major players of the Civil War, perhaps because he had such a diverse career. He was on the forefront in the fight to abolish slavery. He helped found the Free Soil and Republican Parties. As a member of the famous "Team of Rivals" on Abraham Lincoln's cabinet, he funded the Union during the Civil War and remade the nation's banking and currency. He presided over the judicial rulings of the Reconstruction era. If he had achieved his greatest ambition, to be president, there is no doubt every student in America would know his name.

Chase himself disliked his name. Salmon Portland Chase, named after an uncle, was born on January 13, 1808, in Cornish, New Hampshire. After his father's death, the young Chase was sent to live with his uncle Philander Chase, the Episcopal bishop of Ohio. In 1822, Philander Chase was made president of Cincinnati College, and he moved his family to that city, into a six-room cottage at the northwest corner of Fifth Street and Lodge Alley. Salmon Chase, at age fourteen, enrolled in the college as a freshman, but found the curriculum unchallenging. After less than a year, the elder Chase took the family back to New Hampshire, where Salmon graduated from Dartmouth College. He became an attorney in Washington, D.C. Judge Jacob Burnet, a Cincinnati jurist serving as a senator, encouraged Chase to return to the Queen City to practice law.

Chase arrived in Cincinnati on March 13, 1830, finding the city much changed. The boom years were just beginning, and in the next decade, Cincinnati would become one of the largest cities in the country and the center of activity in the West. Cincinnati was a border city; slavery was legal across the river in Kentucky, and the city's business interests were predominantly Southern. But Chase retained his Yankee upbringing, especially in regards to the slavery issue. He set up his law office at the northeast corner of Third and Main Streets. A historical marker notes the location today.

Chase suffered personal tragedy at home, losing two wives and three children to illnesses, so he poured himself into his work. Racial riots in Cincinnati in 1836 awakened the activist in him. He witnessed mob violence against black residents and the destruction of the presses of the abolitionist newspaper *Philanthropist*, which Chase helped editor James G. Birney rebuild. Birney then got Chase involved as defense attorney in local Fugitive Slave Law cases, taking one all the way to the U.S. Supreme Court, which earned him a reputation as the "Attorney General of Runaway Negroes." Although Ohio was a free state, by law runaway slaves found in the state had to be returned to slavery. Chase argued that slavery was a state issue, not a federal one, and that if a slave were to step into free territory he did not carry his status as a slave with him. Chase's arguments were unsuccessful, but he was laying the legal groundwork for the abolition of slavery.

As politics took precedence over the law for Chase, he "staked his political future on the antislavery cause,"[51] aligning with whatever political party had the most effective stance on the issue. He served on the Cincinnati City Council as a Whig in 1840 and then was a leader in the Liberty Party in Ohio in the 1840s. He helped found the Free Soil Party (coining the motto "Free Soil, Free Labor and Free Men") and served as a U.S. senator (1849–1855). Chase then helped to establish the Republican Party and was elected to two terms as the governor of Ohio (1856–1860). In Congress, during the heady days before the Civil War, Chase opposed the Compromise of 1850, refusing to appease the Southern slave states over the expansion of slavery. The law passed anyway, and tensions were boiling toward some sort of eruption. Chase knew the time was right for a Republican to win the White House, and few had done more for the party than he had.

Chase was a formidable man, six-foot-two with a hefty build, clean-shaven, with a receding hairline that made his head appear larger. President Lincoln remarked, "Chase is about one and a half times bigger than any man I ever knew,"[52] though he was commenting on Chase's stature rather than his size. Chase was ambitious and headstrong, and the combination made him many

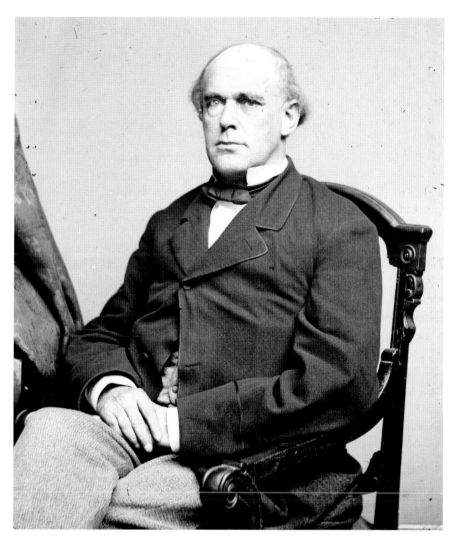

A portrait of Salmon P. Chase, believed to be by famed photographer Matthew Brady during the Civil War, shows the statesman at the height of his career. *Courtesy of the Library of Congress.*

political enemies. Yet he was genuine in his concern for oppressed people, a position that created impediments to his aspirations. Politician Carl Schurz said that Chase was a victim of his ambition, "possessed by the desire to be President, even to the extent of honestly believing that he owed it to the country and that the country owed it to him that he should be President."[53] Having narrowly missed out on the Republican nomination for president in

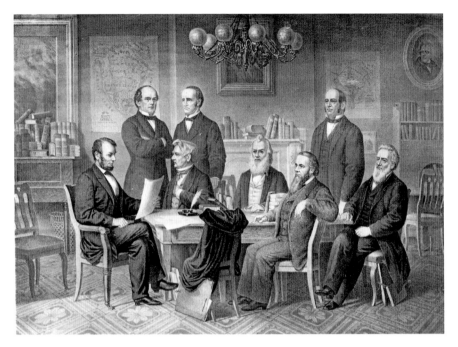

Secretary of the Treasury Salmon P. Chase stands beside President Abraham Lincoln as he shares the Emancipation Proclamation with his cabinet. *Courtesy of the Library of Congress.*

1856, Chase was an early frontrunner in 1860, but the party's nod ultimately went to Lincoln.

The election of Lincoln prompted several Southern states to secede from the Union, and the crisis escalated into war. Needing political support, Lincoln appointed his respected rivals to cabinet positions; Chase was chosen as the secretary of the treasury for his political support rather than for an aptitude in that field.

Chase was tasked with funding the government and the war at a time when financial and banking confidence was low. Most people expected the war to not last long; but, as it ran on, the usual means of raising funds—tariffs and taxes—were insufficient, and banks demanded prohibitively high interest rates on loans. So, in 1861, Chase issued demand notes that could be exchanged for coins. Demand notes were the first national paper currency in the United States. They were called "greenbacks" because of their distinctive green ink. The next year, the Legal Tender Act replaced demand notes with U.S. notes, also called greenbacks, which were backed not by gold but by the government's assurance of their worth. The currency was not without controversy, but it

paid for the war. To raise his visibility, Chase put his own image on the one-dollar bill.

Chase's plan for a national banking system took shape over the next years of the war. Through the National Banking Acts, an incorporation of national banks was created and a single national paper currency was established, which wiped out the thousands of separate notes issued by state banks. This is the foundation for our current banking and currency systems.

In tribute, Chase was put on the $10,000 bill, the largest note in public circulation, first issued in 1928 and discontinued in 1969. Only 336 bills have survived; most are in the hands of collectors.

Throughout his tenure as secretary of the treasury, Chase frequently butted heads with the president, in part because Chase felt he was best suited for that position. Four times he handed in his resignation, but he knew that Lincoln could not afford to lose him during the war—until Lincoln surprised everyone by accepting the fourth resignation, in June 1864. "Chase has fallen into two bad habits," Lincoln confided to Treasury Registrar Lucius Chittenden. "He thinks he has become indispensible to the country; that his intimate friends know it, and he cannot comprehend why the country does not understand it. He also thinks he ought to be the President; he has no doubt whatsoever about that." Chase's ambition made the working relationship miserable for both men. "And yet," Lincoln added, "there is not a man in the Union who would make as good a chief justice as Chase."[54]

Upon the death of Chief Justice Roger B. Taney, Lincoln nominated Chase for the Supreme Court on December 6, 1864, and he was unanimously confirmed by the Senate the same day. The Chase court was a

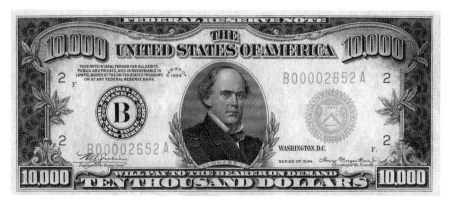

In recognition for creating the first national paper money to help fund the Civil War, Salmon P. Chase appears on the $10,000 bill. *Courtesy of U.S. Department of the Treasury.*

far cry from Taney's, which had made the infamous Dred Scott decision, ruling that slaves who lived in free territory were not free and that black people could not be citizens of the United States. As chief justice, Chase administered the oath of office for Lincoln's second inauguration and for the emergency inauguration of Andrew Johnson on April 15, 1865, following Lincoln's assassination.

Chief Justice Chase presided along with the Senate in the historic impeachment trial of President Johnson in May 1868. The proceedings were purely political. The radical Republicans had been frustrated by Johnson vetoing their Reconstruction bills. Johnson was acquitted by a single vote.

Chase didn't let being chief justice deter his desire to be president. While on the bench, he campaigned for the nomination for president in 1868, this time as a Democrat. His bid failed at the convention. Ultimately, Chase's ambition to be president kept him from that prize.

Chase died on May 7, 1873, in New York City. He was buried in Washington, D.C., and then reinterred in Cincinnati's Spring Grove Cemetery. In 1877, the Chase National Bank was founded and named in his honor. The bank has kept the Chase name prominent, even if few people today know of its association with the man.

8

THE SIEGE OF CINCINNATI

C incinnati was not a Civil War battle site. It is not listed with the hallowed
names Antietam, Shiloh, Fredericksburg, Chickamauga and Gettysburg.
Nor did it share the fate of Atlanta, burned to the ground in the hell of war.
But either of those fates was a real possibility in September 1862, when the
Confederate army was forging its way through Kentucky. The commonwealth
was a border state, still a part of the Union but also a slave state, and many
Kentuckians were sympathetic to the rebel cause. In the second year of the
war, the Union army had been mostly ineffectual, and the Confederates had
the advantage. On August 30, 1862, Confederate major general E. Kirby
Smith captured Richmond, Kentucky, and three days later, Lexington cheered
the arrival of the Confederates. Word reached Cincinnati of the encroaching
rebel army, and the city's residents feared they were next.

The Union lacked sufficient military forces in the region, yet Major
General Lew Wallace was tasked with finding a way to protect the city from
pillaging and destruction from a Confederate invasion. Wallace would go on
to write the novel *Ben-Hur: A Tale of the Christ*, one of the bestselling books
of all time, but in 1862, he was out of favor with the leaders in Washington
over the high casualties at the Battle of Shiloh. On September 1, Wallace
was ordered to Cincinnati to assume command of the city and the northern
Kentucky towns of Covington and Newport. But there was no army, just a
smattering of troops stationed nearby.

Wallace took up headquarters in the Burnet House and met with
Cincinnati mayor George Hatch to declare that the cities would be placed

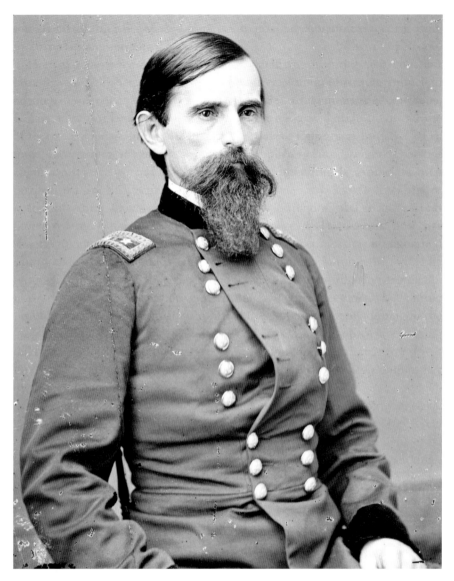

Major General Lew Wallace assumed command of Cincinnati, Covington and Newport and defended them from Confederate forces during the siege of Cincinnati. *Courtesy of the Library of Congress.*

under martial law, with the Cincinnati police acting as a provost guard. The next morning, the newspapers ran Wallace's proclamation, informing the citizens that "an active, daring and powerful enemy threatens them with every consequence of war."[55] All businesses would close, the ferries would

cease operations, and the people were called on to assist in preparations to defend the city, with "citizens for the labor, soldiers for the battle."[56] Mayor Hatch ordered that "all persons, employers and employees assemble in their respective wards at the usual place of voting" to get their assignments, and that "every man, of every age, be he citizen or alien, who lives under the protection of our laws is expected to take part in the organization."[57]

"The time for playing war has passed," the *Cincinnati Gazette* declared. "The enemy is now rapidly approaching our doors. Kentucky has been successfully invaded, and Cincinnati is now, for the first time since the commencement of the rebellion, seriously threatened....The great duty of the people now is to unite and rise like one man and prepare to resist the approaching foe."[58] In the first two days, 14,000 men reported.

That didn't count the black citizens. Peter Humphries Clark, a black abolitionist writer, reported another side of the siege of Cincinnati in his 1864 pamphlet *The Black Brigade of Cincinnati*. "The city of Cincinnati always has been, and still is, pro-slavery," Clark wrote. "Nowhere has the prejudice against colored people been more manifested than here."[59] When the war began, African American men had come forward to defend their city, only to be told by police, "This is a white man's war, and you damned n——s must keep out of it."[60] Earlier that summer, Cincinnati had erupted in a race riot, triggered by racial tensions between African American and Irish stevedores working on steamboats. On July 10, a mob of whites fought with black stevedores on the levee. Then, after most of the police force was sent to defend Lexington from Confederates led by John Hunt Morgan, a mob of a thousand men forged through Bucktown, the predominantly black slums, and most of the black population fled the city until tempers calmed.

When Mayor Hatch had called for "every man, of every age, be he citizen or alien," it was understood that he didn't mean black people. Furthermore, since African Americans couldn't vote, they had no "usual place of voting" at which to meet. On September 2, the special police, consisting of many of the ruffians who had clashed with blacks in July, rousted black men from their homes and marched them like felons at the point of bayonets, some to a holding pen on Plum Street opposite St. Peter in Chains Cathedral; others were conscripted to labor. None of the newspapers protested the behavior except the *Gazette*, which pleaded, "Since the services of men are required from our colored brethren, let them be treated like men."[61]

Disturbed by the harsh treatment of the men, Wallace asked respected local judge William Martin Dickson to take command of the black forces. Dickson created the Black Brigade of Cincinnati to work as laborers to

construct the defenses. They marched under the U.S. stars-and-stripes flag marked with the words "Black Brigade of Cincinnati." Afforded the dignity of volunteering, compared to the four hundred conscripted by the police, close to one thousand black men answered the call.[62]

Wallace's plan was to set up defenses at the hills south of Covington and Newport. He ordered the completion of Fort Mitchell, which had been started by General Ormsby MacKnight Mitchel, who built the Cincinnati Observatory, for the placement of cannons. More cannons were placed atop Price's Hill and Mount Adams. Several miles of breastworks and rifle pits were dug out along the bend in the Ohio River on the Kentucky side. The Black Brigade, armed with only shovels, were among those sent out to dig, sometimes as far as a mile from the fortifications without weapons and with the Confederate army on the way.

There was no bridge across the Ohio River. Construction of the John A. Roebling Suspension Bridge had been halted by the war; only the piers were erected. Ferries were insufficient for getting the soldiers across the river, so Wallace consulted Cincinnati architect Wesley Cameron about building a pontoon bridge. Cameron said that one could be built in forty-eight hours, a claim that astounded Wallace, since a pontoon bridge at Paducah, Kentucky, had taken engineers three months. Men latched together coal barges lying near the Licking River and, in thirty hours, had completed a pontoon bridge that could carry two army wagons abreast.

As fortifications were under way, soldiers poured in from across the region, mostly from Ohio. Wallace counted 72,000 men on September 5, 60,000 of who were irregular soldiers. The irregulars, armed with pistols, shotguns and sporting rifles, were called Squirrel Hunters, "a backwoods lot, many in coonskin caps and homespun" who "came into town just itching for a fight."[63]

Wallace placed 55,000 men behind the breastworks and rifle pits and stationed 15,000 as guards at fordable locations along the river, which was at its lowest point. The rest of the men were spread among sixteen steamboats, each armed with two six-pounder guns. To communicate down the line, a telegraph wire was set up along the breastworks. Wallace moved his headquarters to Covington to be closer to the line.

On the Confederate side, General Kirby Smith had split his Kentucky forces into two columns, leading one himself to Frankfort. They easily captured the state capitol on September 3. The other column of 9,000 men, under Brigadier General Henry Heth (pronounced Heeth), went north to Cincinnati. Believing the city defenseless, there was no hurry,

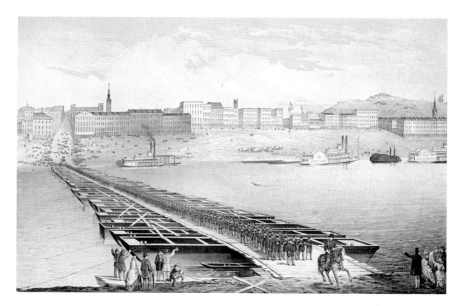

A regiment crosses the pontoon bridge at Cincinnati on September 13, 1862. The pontoon bridge, built in just thirty hours, allowed the soldiers to easily cross to the Kentucky hills to defend the city. *Courtesy of the Library of Congress/A.E. Mathews.*

and on September 10, the Confederates camped about one mile south of Fort Mitchell.

The next day, September 11, was a tense standoff. Wallace sent men to the Confederate camp, claiming to be searching for runaway slaves, while Heth sent farmers to pass through the Federal fortifications; both were spying on the enemy's forces. Standing atop the parapet of Fort Mitchell, Wallace could see Heth through his field glasses, looking back. There were a couple of minor skirmishes with a few casualties, but no other engagement. In the morning, messengers reported that the Confederate camp was deserted. The Rebels had skedaddled. What Wallace did not know was that in the night, Heth had received orders from Smith to join General Braxton Bragg for an attack on Louisville, which never materialized. Hearing the news, someone started singing "John Brown's Body" (the same melody as "The Battle Hymn of the Republic"), and 72,000 voices of soldiers and citizens rang out through the Kentucky hills.[64]

Cincinnati burst out in cheers and relief. A procession of soldiers marched through the city as people jammed the streets, waving banners and celebrating their brave, patriotic citizens. On September 15, Wallace addressed the people of Cincinnati, Covington and Newport:

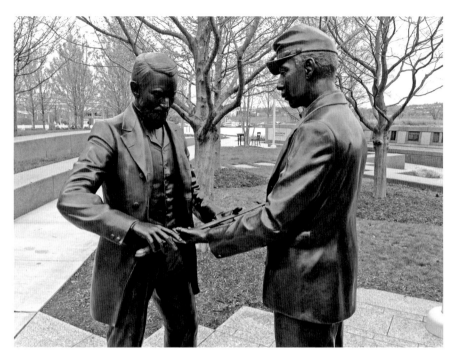

The Black Brigade monument at Smale Riverfront Park depicts Marshall P.H. Jones presenting Judge William M. Dickson with a ceremonial sword. No photos of Jones exist, so sculptor John Hebenstreit used Judge William Mallory Sr. as a model. *Courtesy of Jeff Suess.*

In coming time, strangers, viewing the works on the hills of Newport and Covington will ask, "Who built these intrenchments?" You can answer, "We built them." If they ask, "Who guarded them?" you can reply, "We helped in thousands." If they inquire the result, your answer will be, "The enemy came and looked at them, and stole away in the night."[65]

The Black Brigade disbanded on September 20 and had its own parade to Fifth and Broadway, where it presented to its commandant, Dickson, an engraved sword as a token of the men's esteem. A Black Brigade monument at the city's Smale Riverfront Park commemorated the 150th anniversary in 2012. The monument tells the brigade's story and has bronze statues depicting Marshall P.H. Jones handing the sword to Dickson. Dickson was killed in a tragic accident on the Mount Auburn Incline on October 15, 1889.

The Black Brigade was the first African American unit organized for the North. The brigade had one casualty, Joseph Johns, who died when a tree

fell on him. Powhatan Beaty of the Third Regiment, Company No. 1, was later awarded the Medal of Honor for taking command of his company in the 127th Ohio Volunteer Infantry during the Battle of Chaffin's Farm when the officers had been killed or wounded. Several others from the Black Brigade would go on to serve in the 54th Massachusetts Regiment (depicted in the film *Glory*). The members of the Black Brigade were justifiably as proud as the other citizens who had defended their city, as Clark pointed out: "While the fortifications erected by their own hands had deterred the enemy from attacking in front, their uniform good conduct had completely routed the horde of rebel sympathizers in the rear."[66]

9
THE MAN BEHIND MCCLELLAN

Any history book on the Civil War will have plenty to say about General George B. McClellan, from his meteoric rise as the "Young Napoleon" of the Union army to his military failures and his presidential campaign against Abraham Lincoln. But little has been written about the general's "confidential aide," Colonel Thomas M. Key, a Cincinnati judge and politician who advised McClellan and shaped his career.

Historian William B. Styple stumbled on Key in an unpublished letter by Union general Philip Kearny telling of an unauthorized, secret meeting in June 1862 between Key and Confederate general Howell Cobb. Kearny had suspected treason or at least some political game. Intrigued, Styple searched for more information on McClellan's man, but not much was known about Key. McClellan's posthumous autobiography, *McClellan's Own Story*, refers to Key only a few times, and simply as his aide-de-camp. Key had fallen through the cracks of history.

Key's will had instructed his close friend and law partner, Judge William M. Dickson—the same man who commanded the Black Brigade—to "destroy every paper belonging to me."[67] But Styple kept digging through the papers that couldn't be burned: army records, friends' letters and diaries and newspapers. "The more pieces of the Key puzzle I found, the more disturbing the picture became," Styple said.[68] He put together the facts about the elusive Key in his book *McClellan's Other Story*.

Thomas Marshall Key was born in Washington, a town along the Ohio River in Mason County, Kentucky, on August 8, 1819. A relative of Chief

Justice John Marshall, he became judge of the Commercial Court of Cincinnati and practiced law with Dickson and Alphonso Taft, father of William Howard Taft. Judge Key also served in the Ohio Senate from 1853 to 1861, where he wrote the Married Women's Act, guaranteeing property rights for married women in Ohio, and earned a reputation as the "Great Compromiser."

There are no known photographs of Key, though Dickson provided a brief description: "He was a handsome man, rather above medium size, not stout, a manly face with a firm but a genial expression and a smile as lovely and bewitching as a woman's."[69]

Key's path intersected with McClellan's in 1860. McClellan had been a railroad executive in Chicago when he was appointed superintendent of the Ohio & Mississippi Railroad at one of the highest railroad salaries in the country. He moved to Cincinnati and rented a comfortable house at Third and Pike Streets, while Key boarded nearby at the Spencer House on the Public Landing. The two men shared the same political beliefs and became fast friends. As conservative Democrats, they blamed the coming war on rabid Southern secessionists and radical abolitionists and were openly critical of President Lincoln, whom McClellan viewed as uncultured and "nothing more than a well meaning baboon."[70] Once fighting broke out at Fort Sumter in April 1861, McClellan and Key supported the Union but believed the war should be ended without the forced abolition of slavery.

A veteran of the Mexican War, McClellan was appointed major general of the Ohio militia. Key joined his staff, though his role is somewhat foggy. His official position was as aide-de-camp, but he also acted as a judge advocate

There are no known photographs of Colonel Thomas Marshall Key, who is buried in Spring Grove Cemetery. *Courtesy of Jeff Suess.*

and was often called that in news reports. "Key and McClellan were each others' alter ego," Styple said. "They both agreed that the upcoming conflict was more of a political disagreement than outright war. They could work together to end the conflict—for McClellan had the military skill and Key had the political skill."

Whatever Key's official role, he served as McClellan's confidential aide, a kindred spirit who influenced and guided him, for good or ill. Styple uncovered evidence of Key's fingerprints in the political maneuvering that made McClellan head of the Army of the Potomac and general-in-chief of the Union army. Key's name also popped up in the oddest places: in unauthorized meetings and negotiations, in interrogations to learn of the enemy's strength and in prisoner exchanges with Allan Pinkerton, the founder of Pinkerton's National Detective Agency and the chief of the Union Intelligence Service.

Key stayed out of the limelight and rarely took credit for his accomplishments. Though he was a Democrat and advocated against forced abolition, Key hated slavery and authored the District of Columbia Compensated Emancipation Act in 1862, a federal law that abolished slavery in Washington, D.C., and paid slaveholders $300 for each slave freed and $100 for each slave who chose emigration.[71]

Meanwhile, McClellan's military career sputtered and stalled. As the war continued into its second year, Little Mac's reticence to engage the enemy in battle lost him support in Washington. Historians have written tomes trying to figure out McClellan's military failures, but those who knew McClellan and Key offer insights into Key's influence. Dickson, who served with both men at army headquarters, wrote that "Key's stronger nature dominated McClellan and thus through him, Key, unseen, was for a time a veritable force in affairs, the power behind the throne."[72] William J. Biddle, another aide-de-camp under McClellan, wrote that Key was "one of those most devoted friends of McClellan who were not always his safest advisers, and who persuaded him, probably more than once, to hold his command, hoping (almost against possibility) for success" against political rivals.[73]

If McClellan and Key were playing a political game, they were surprised to find that everyone else was playing for keeps. At Key's meeting with General Cobb—the one that raised the ire of General Kearny—the unauthorized peace parley about what it would take to end the war awakened Key to the fact that "those leaders on the other side talk as if they would fight."[74]

The political machinations of McClellan and Key culminated in the infamous "Harrison's Landing Letter." After the Battle of Malvern Hill in

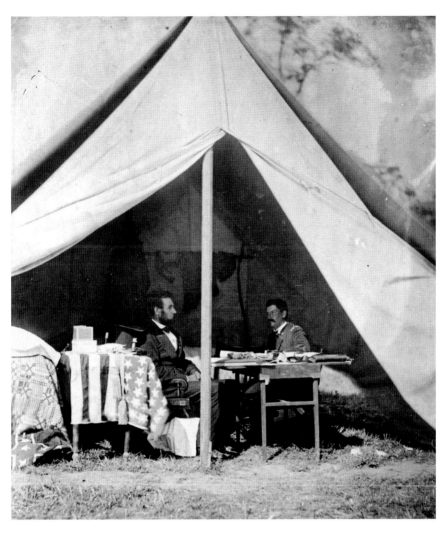

President Abraham Lincoln meets with General George B. McClellan in McClellan's tent on the battlefield on October 3, 1862, after the costly Battle of Antietam. *Courtesy of the Library of Congress/Alexander Gardner.*

July 1862, at the end of the Seven Days Battles, instead of pursuing the Confederates, McClellan retreated to Harrison's Landing, Virginia, and wrote a letter to Lincoln, advising him not on military matters but on politics. McClellan wrote that the aim of the war should be to preserve the Union, not to free the slaves, and that, if the conflict were to become a war over abolition, the soldiers would abandon the cause. McClellan brazenly presented the letter to Lincoln in person.

The impudent letter is credited to McClellan, though Styple's analysis of passages similar to Key's writing indicates that Key was likely the coauthor, even if the sentiment was McClellan's.[75] Biddle wrote, "I have long felt sure that *his* [Key's] influence was the cause of McClellan's sending the 'Harrison's Bar' letter…and that to *his* inspiration is to be ascribed much of its manner and of its matter."[76]

Lincoln said nothing about the letter, quietly folded the paper and put it away, but he had lost all confidence in his general-in-chief. When McClellan was again overly cautious and failed to pursue General Robert E. Lee after the bloody Battle of Antietam in September 1862, allowing the Confederates to escape, Lincoln had had enough and removed McClellan from command.

McClellan and his aide resurfaced in the 1864 presidential election. Politics had been their game all along. The "Harrison's Landing Letter" became McClellan's platform as the Democratic candidate running against Lincoln. Although McClellan was not personally against the war, the Democrats campaigned on a platform to end the war at any price and negotiate with the South. Cincinnati native George Hunt Pendleton, a noted Peace Democrat, was chosen as his running mate. McClellan concentrated on attracting the army vote, as he was a popular commander. The Republicans ran under the name National Union Party that year, to attract War Democrats. The American people were so weary of the war that Lincoln feared a McClellan victory. But General William Tecumseh Sherman's burning of Atlanta helped turn the tide for the Union, and Lincoln won reelection handily. McClellan won only three states; 78 percent of the vote from army soldiers went to Lincoln.[77]

After the war, Key became gravely ill from a condition he obtained at Antietam. He died in his home in Lebanon, Ohio, on January 15, 1869, and is buried in Spring Grove Cemetery. Key's law partner, Dickson, then complied with his wishes and burned all his papers.

Nearly twenty years later, Colonel Donn Piatt, who had known Key for years, exposed the most damning portrait of the man:

> [McClellan] *had an evil genius unknown to himself and unknown to both friends and enemies.…*
>
> [Key] *procured a position on McClellan's staff, and not only won the confidence of his general, but, from an eccentricity of genius, sought to lose himself in the man. He seemed satisfied in his self-immolation through the sense of power it gave, and the strong assertion of the peculiar views with which the confidential aid was penetrated.…*

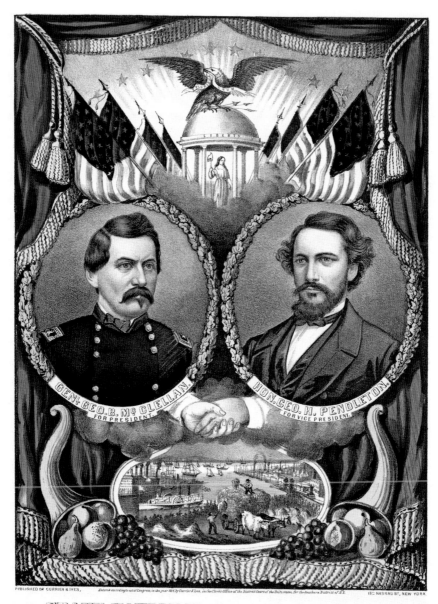

A campaign banner promotes George B. McClellan and George Hunt Pendleton for the Democratic presidential ticket in 1864, running against Abraham Lincoln in the midst of the Civil War. *Courtesy of the Library of Congress/Currier & Ives.*

Key soon possessed and controlled McClellan without the soldier's being aware of his lost identity. He died in this ignorance, and the man speaking through him, and who proved his ruin, was as unknown to his victim as he is to the world….

Key was his evil genius.[78]

Piatt does give Key some credit.

Looking back, it is astonishing to note the amount of important work accomplished by the man so unknown to history. All the time McClellan was organizing about Washington, Key was busy bringing about the abolition of slavery in the District of Columbia.[79]

Piatt concluded of Key's hold over McClellan: "The man who honestly sought to make him great made him a failure." He added that "obscurity suited Key," but that someone should inscribe upon his tomb, "*The Evil Genius of George B. McClellan!*"[80]

THE *SULTANA* TRAGEDY

The worst maritime disaster in American history hasn't just been forgotten; it was hardly even noted at the time. As incredible as that may seem, the date of the tragedy is significant: April 27, 1865. That was a turbulent month. On April 9, General Robert E. Lee surrendered his Confederate forces to General Ulysses S. Grant at Appomattox Court House, Virginia, effectively ending the fighting of the Civil War. On April 14, President Abraham Lincoln was attending a show at Ford's Theater when John Wilkes Booth shot him in the head. Lincoln died the next day. A manhunt for Booth culminated in the assassin's death twelve days later. The war was ending, the troops were coming home and Confederate leaders were on the run, all of which dominated the headlines late in April. So when the steamboat *Sultana*, overloaded with Union soldiers newly freed from hellish Confederate prison camps, exploded and sank near Memphis, Tennessee, it was just another tragedy to a nation that had grown accustomed to them.

The fateful *Sultana* had its origin in a Cincinnati shipyard. The steamboat was built at the John Litherbury boatyard on Front Street (now Riverside Drive), where the Theodore M. Berry International Friendship Park now runs along the Ohio River. In January 1863, local manufacturers and craftsmen fitted the hull and superstructure with the engine and accommodations. Moore and Richardson, engine builders on Front Street, constructed the pair of thirty-four-foot-diameter waterwheels and the four high-pressure tubular boilers that produced more steam for the engine.

The steamboat measured 260 feet long, 39 feet wide at the base and 42 feet wide at the beam, with a hold 7 feet deep. Despite its size, it could glide on a draft, or minimum depth, of just thirty-four inches. Steamboats were floating hotels with the necessary amenities. There were rooms for 76 cabin passengers on the second deck and space for 300 deck passengers on the main deck, for a legal passenger capacity of 376, plus 85 crew members. The steamboat, costing $60,000, was constructed for Captain Preston Lodwick, who named it *Sultana*, meaning "the woman of a sultan."

The *Sultana* set out on its inaugural trip to Pittsburgh on February 3, 1863. The *Cincinnati Commercial* called it "one of the largest and best business steamers ever constructed."[81] The *Sultana* plied the Ohio and Mississippi Rivers, making most of its money transporting Union soldiers throughout the war. The government paid five dollars for transport of soldiers and ten dollars for officers. Within a year, Lodwick made back double his investment and sold the ship, with portions of ownership split among several parties, including Captain J. Cass Mason, who then became captain of the vessel. As it became clear in the spring of 1865 that the war would be ending, there would soon be more traffic for transporting troops wanting to get home.

On April 13, the *Sultana* left St. Louis down the Mississippi River, bound for New Orleans. Along the way, while the ship was docked at Cairo, Illinois, on April 15, word reached the city of Lincoln's assassination, and the *Sultana* was the first to deliver the dire news to the Deep South. Upon reaching New Orleans, Captain Mason took the boat back upriver a few days later and on April 23 pulled into Vicksburg, Mississippi, where chief engineer Nathan Wintringer requested repairs for a boiler leak. There, some Union soldiers paroled from prison camps awaited transport.

Early in the war, Union and Confederate prisoners of war were exchanged man for man, with the promise that a released prisoner would not take up arms again, though that provision was rarely heeded. As the war dragged on, the North decided that keeping prisoners would deprive the South of much-needed soldiers, and the exchange releases stopped. That also meant that Union soldiers languished in Confederate prison camps. Cahaba Federal Prison in Cahaba, Alabama, opened in 1863 and was quickly overcrowded. The freshwater stream that flowed into the prison was tainted by the town's washing and sewage. A new prison was opened near Andersonville, Georgia, in February 1864; Cahaba was supposed to close, but it became a holding area for prisoners to be transferred to Andersonville and remained open. Conditions in Andersonville were horrific. A prison designed for 10,000 men swelled to more than 30,000, and prisoners suffered from diarrhea,

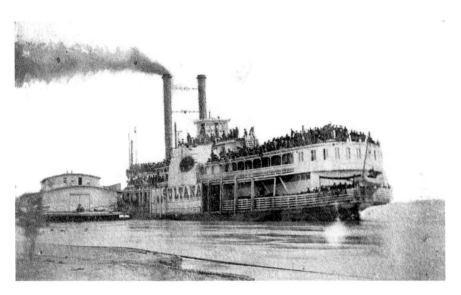

The severely overloaded *Sultana* stopped briefly at Helena, Arkansas, on April 26, 1865, the day before the steamboat exploded. Many of the more than 2,000 Union soldiers on board rushed to the rails to be photographed, nearly capsizing the steamboat. *Courtesy of the Library of Congress/Thomas W. Bankes.*

scurvy, dysentery and a host of other diseases, as well as severe malnutrition. Nearly 13,000 prisoners died at Andersonville. In March 1865, as the war was nearing an end, the exchange releases were reinstated, and prisoners from Cahaba and Andersonville were allowed to go home.

Trains loaded with paroled prisoners, mostly from Cahaba, pulled into Vicksburg to be transported by steamboat up to Cairo. There was some squabbling over which ship would take them, and there were allegations of bribes—transporting troops was lucrative business—but in the end, the soldiers were loaded onto the *Sultana*. Attempts to count them all were ineffective, and official numbers vary from 1,800 to 2,200. Adding in about 100 civilian passengers and 85 crewmembers, the total number of people aboard the *Sultana* was about 2,300, five times the legal capacity.

The *Sultana* departed Vicksburg early on April 25, and thirty hours later stopped briefly at Helena, Arkansas. Townsfolk came to see the boat, and photographer Thomas W. Bankes captured an image of the *Sultana* bloated with passengers. The soldiers, each wanting to get into the photograph, had rushed to the rails on one side, and this threatened to capsize the boat. The *Sultana* continued on to Memphis that night and then pushed off again shortly after midnight, overloaded with soldiers; a cargo of horses, mules and casks of sugar; and its mascot, a caged seven-foot alligator.

At 2:00 a.m. on April 27, one of the boilers exploded. Two other boilers followed. The blasts propelled debris and people alike one hundred feet into the air, and both rained down on the deck and into the water. Men, scalded by steam and boiling water, had their skin slide off their bodies. Sleeping passengers awoken by the blast scurried to flee the spreading fire, and a panicked stampede crushed many underfoot. There were no lifeboats and only a few life preservers. Women jumped overboard with their babies; wearing their life preservers too low, they promptly sank. Many passengers were too wounded or weak from imprisonment to get off the boat. Others couldn't swim. The choice was either stay aboard to roast in the flames, or jump into the freezing water and certainly drown. Injured soldiers pleaded for help to be dropped overboard, preferring the river as their fate, and their comrades complied, performing the hardest tasks of their lives. The water was black with bodies. Those who jumped dragged others underwater trying to use flotsam as buoys. As the flames devoured the boat, the smokestacks and paddle wheels fell, crashing down on people struggling to survive. The initial blast was heard seven miles away in Memphis, but no one investigated the source. No steamboat was coming to the rescue. Due to flooding, the

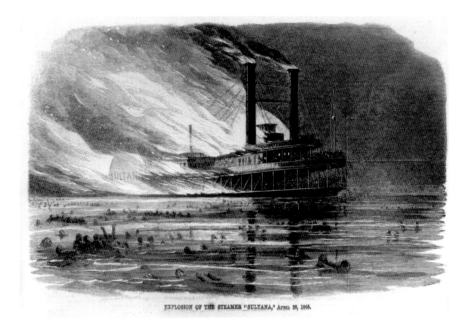

A woodcut from *Harper's Weekly* from May 20, 1865, depicts the explosion of the steamer *Sultana*, resulting in the deaths of about 1,800 people. *Courtesy of the Library of Congress/* Harper's Weekly.

shore was miles away in any direction, and many people grew too tired to keep swimming. The *Sultana* and most of the passengers and crew sank to the bottom of the Mississippi.

Numbers are never certain in such cases. Since there were no accurate accounts of how many people were aboard, it is impossible to tell how many died. The government listed the number of dead at 1,238—a gross underestimate. U.S. Customs placed the figure at 1,547, which is the one most often cited. But the government numbers undercount the passengers and don't figure the more than 200 who succumbed to their injuries within days of the explosion, leaving the number of survivors at about 550. Historians count close to 1,800 dead, more than the 1,517 on the RMS *Titanic*, making the *Sultana* the deadliest maritime disaster in U.S. history. Of the casualties, Ohio lost 791, over 50 of them from Cincinnati.[82]

News of the tragedy was slow to spread and was lost among dispatches from the conclusion of the war. After the disaster, there was much finger-pointing, blaming the boiler explosion on the engineer Wintringer, who survived, or Captain Mason, who did not. Blame was also directed to the officers who allowed the overcrowding. There were accusations of government kickbacks for transporting troops. In the end, no one was really held accountable, although everyone involved carried some scars from the ordeal.

The survivors held periodic reunions in Knoxville, Tennessee, over the years, shared their accounts, and lamented that the *Sultana* never penetrated the national attention. In 1892, survivor Chester D. Berry wrote, "The idea that the most appalling marine disaster that ever occurred in the history of the world should pass by unnoticed is strange, but still such is the fact, and the majority of the American people today do not know there ever was such a vessel as the 'Sultana.'"[83]

Over the decades the path of the Mississippi River has shifted. In 1982, historian Jerry Potter found what he believed are the remains of the wreckage of the *Sultana* in a soybean field in Mound City, Arkansas, where the river formerly flowed. In Cincinnati there is a historical marker at Sawyer Point, near where the steamboat was built. Though the *Sultana* is familiar to historians and history buffs, it was a national tragedy that should be remembered by all.

THE FIRST TRAIN ROBBERY

B efore there was the Old West, stretching from the Mississippi River to the California coast, there was the original West—the territory west of the Appalachian Mountains anchored by cities like Cincinnati, Louisville and St. Louis. Railroads stretched the country farther west in the 1860s, giving rise to the wild, lawless days of cattle ranchers and gunfighters. But for a few years, the Midwest on the fringes was caught up in that storm.

The first train robbery in the United States was committed on May 5, 1865, just outside of North Bend, Ohio, a few miles downriver from Cincinnati. As described in reports in the Cincinnati newspapers, during the day of May 5, a group of fifteen to twenty men crossed the Ohio River from Kentucky on skiffs to the Ohio & Mississippi Railroad tracks running along the river. About seventeen and a half miles west of Cincinnati, the robbers displaced one of the rails on the track between the stations at North Bend and Gravel Pit.

The regular 8:00 p.m. express train bound for St. Louis left the Cincinnati depot at West Front Street on the corner of Mill Street, approximately where Mehring Way meets Gest Street on the riverfront. The train consisted of the steam engine *Kate Jackson*, four passenger coaches fully loaded with about one hundred men and women, a baggage car and the Adams Express Company car, which was probably the primary target of the robbers. Adams Express was a delivery service that also served as the paymaster for both the Union and Confederate armies during the Civil War.

Around 9:00 p.m., the train hit the dismantled track. The locomotive ran off the rails, tipped over and smashed on its side, capsizing the Adams

THE OHIO AND MISSISSIPPI DEPOT.

The Ohio & Mississippi Depot on West Front Street at Mill Street served the Ohio & Mississippi Railroad, which suffered the first-ever train robbery down the line just west of North Bend, Ohio. *From* Illustrated Cincinnati.

Express car and baggage car with it. The lead passenger coach then rammed into the baggage car, causing considerable damage, but the rest of the cars stayed on the track. The passengers suffered no worse than a few broken bones. A report obtained from officers and passengers, published in both the *Enquirer* and the *Commercial*, captured the drama of the incident:

> *The first shock of the crash of course awakened in the minds of the passengers the idea that it was an ordinary railroad accident, but the volley of firearms, and the shouts outside, which followed immediately after, undeceived them, and the nature and cause of the mishap became palpably evident when two desperadoes made their appearance at each car, and backed by two more who kept guard outside, commenced pillaging the passengers.*[84]

The robbers, armed with silver-mounted Colt Navy revolvers, took advantage of the confusion and barked orders, uttered "the vilest oaths" and demanded the passengers' money and valuables or they "would have their brains blown out." One of the villains declared, "Rob every damned man, but don't hurt the ladies."[85] Most of the passengers were relieved of their money, hundreds and thousands of dollars in some cases, as well as gold watches and diamond pins. But the *Enquirer* reported that a few clever

passengers hid their valuables.[86] The conductor cut a hole in his coat pocket and dropped $320 inside the lining. Women slipped jewelry down into their bodices. A lady unrolled her hair and placed her gold watch, two diamond rings, earrings and $2,000 in her curls, and rolled her hair back up, leaving out a few dollars for the robbers to find. Another fellow smuggled away a cheap watch but forgot about the $2,000 in his pocket. The thieves took $70 from a lumberman who had his hip dislocated in the wreck, yet a soldier who broke a few ribs and had only $6 or $7 to his name was allowed to keep the cash, "that he might need it all."[87] Somehow, one of the passenger cars was overlooked and not robbed.

At the express car, the thieves chopped away with axes to retrieve the three money safes and demanded the keys from the messenger, but two of the three could be opened only at their destination in St. Louis. Unable to force them open with the axes, the robbers turned to gunpowder and blew the safes. A fisherman reportedly witnessed the robbery from his hut on the river and watched the robbers escape on skiffs back into Kentucky.

The passengers hailed the steamer ship *C.T. Dumont* heading into Cincinnati, and several caught a ride back to town. At midnight, the train from St. Louis arrived at the scene, and the remaining passengers continued on to their destination. A temporary track was laid around the wreck so that other trains were not delayed.

The Adams Express Company reported the theft of twenty U.S. 7-30 coupon bonds worth $500 each and ten more worth $1,000 each. The company offered a $500 reward for each person arrested and convicted of the robbery. It also issued a reminder that the bonds were the property of the Treasury Department and that the theft constituted a crime against the government; bankers and brokers were warned about dealing with the stolen bonds.

Military forces were alerted, and a party of sixty men was dispatched in pursuit of the robbers. Initial reports labeled the robbers "guerrillas" and "Rebels," with the prevailing opinion that the perpetrators were among the Boone County, Kentucky guerrillas who had been harassing the Bluegrass State. Bandits and rustlers were born from the Civil War, when the nation was fractured and guns were a way of life. During the war, William Clarke Quantrill led a band of pro-Confederate guerrillas, including outlaws Jim Younger and Frank James, who slaughtered Union troops and Northern sympathizers throughout Kansas and Missouri. Kentucky was rife with bushwhackers and killers using the war as an excuse for their violent activities. In July 1863, Confederate brigadier general John Hunt Morgan and his men

raided Kentucky, Indiana and Ohio, destroying bridges and railroads, and ransacking farms and stores to disrupt the Union and terrorize the Ohio River communities.

The *Enquirer* reported on May 9 that 7-30 bonds worth $12,000 and $1,000 in greenbacks were found in the streets of Verona, in Boone County, Kentucky, about twenty miles from North Bend. On the morning of May 7, a group of armed guerrillas had ridden into Verona, spending lavishly and drinking heavily, and rode out, leaving behind some loot figured to be from the train robbery.[88] Two men were arrested on suspicion of being involved in the robbery, though nothing further was reported.[89] Four men, Booth Henry, James Butts, William Jones and Whedon Sleet, were arrested in Boone County on May 12 in connection with the attack on the

The Adams Express Company offered a reward of $500 for each train robber arrested and convicted, as posted in an ad in the *Cincinnati Daily Gazette* on May 8, 1865. *Courtesy of the* Cincinnati Daily Gazette.

train. "The evidence pointing to the complicity of the parties is said to be quite strong," the *Enquirer* reported.[90] The party of robbers was said to have eaten dinner at Sleet's home before crossing the river for the robbery. Information gathered on the guerrillas indicated that some were farmers, some were former Rebel soldiers and others were "loafers around the small doggeries of the village."[91] The four alleged robbers were handed over to the custody of General Joseph Hooker in Cincinnati, though no further information about their fate has been located. Officially, no one was ever caught.

Some historians consider the North Bend robbery an extension of the Civil War, even though it occurred nearly one month after the surrender of Confederate forces on April 9. A week before the robbery, a circular was distributed from Major General John M. Palmer in Kentucky, warning that there was no longer a Confederate "organization which deserves to be characterized as military" and that "the bands now prowling about the

country are simply guerrillas and robbers, and are to be treated as such."[92] The passengers of the train robbery described all of the thieves as dressed in citizen's clothes, except one in a military-style uniform (whether Union or Confederate was never recorded). One of the men was called "Captain," and another "Lieutenant." Then, consider the injured soldier who was allowed to keep his money. Also, a group of soldiers from the Eighth Infantry was aboard without their weapons, and they were not hassled by the robbers. Could that have been a courtesy granted fellow soldiers?

Other historians argue that if the guerrillas had been Confederates, they surely would have done more to destroy the train and rail lines. Instead, robbery appears to be the sole motive. A few days after the robbery, the *Cincinnati Daily Times* questioned the original theory of Rebel guerrillas, suggesting the villains may have been "a gang of desperate thieves who concocted and executed the plan for the purpose of retrieving their fallen fortunes" and not linked to the Confederate cause.[93]

Newspapers suggested that railroad officers start carrying firearms to thwart future robberies. The train robbery would become a staple of western outlaws. The Ohio & Mississippi Railroad was robbed again on May 22, 1868, by the Reno Gang in what some historians consider the first peacetime train robbery. The James Gang and Butch Cassidy were among the most notorious train robbers and caught the imaginations of Americans who have romanticized such daring heists. And it all started at North Bend.

PART III

QUEEN CITY OF THE WEST

Cincinnati in 1866, as seen from Mozart Hall on the west side of Vine Street north of Fifth Street, had just made it through the Civil War. The John A. Roebling Suspension Bridge, not yet completed, would open that December. *Courtesy of the* Cincinnati Enquirer *archives.*

LAFCADIO HEARN'S HAUNTS

In the tempestuous post–Civil War years, Cincinnati's diverse population was crammed in the basin, brimming with crime and racial tension. The people found an unlikely voice in Lafcadio Hearn, a reporter for the *Cincinnati Enquirer* and the *Cincinnati Commercial* who wrote about the kaleidoscope of city life, specializing in the darkest regions. In Cincinnati, Hearn began a literary career that would span the globe. Though highly regarded as a journalist and chronicler of postbellum America, and honored in his adopted Japan, he remains in the shadows in the city where he came to fruition.

Hearn was the product of a mélange of cultures. He could blend in anywhere but fit nowhere. One biographer called him a "wandering ghost." He made an impression at all of his haunts and then slipped away. He told and retold tales of ghosts all his life and held an endless fascination with the morbid and macabre. Hearn's life echoed his interest in the exotic and ghoulish.

He was born Patrick Lafcadio Hearn on June 27, 1850, on the island of Lefkada, or Lefkas, one of the Ionian Islands near Greece that was the source of his name. He was the child of a love affair between Charles Bush Hearn, an Anglo Irish military surgeon in a British regiment stationed on the island, and Rosa Antonia Cassimati, a Maltese Greek beauty. The couple married and moved to Dublin, but the cold Irish climate was difficult for Rosa. Charles had the marriage annulled, and she returned to Greece. Lafcadio never saw his mother again, and he had infrequent visits from his father. He was raised by his aunt in Dublin and sent to school in Normandy and London.

Lafcadio Hearn was the voice of the unconventional and unheard in Cincinnati in the 1870s, but his bohemian lifestyle was too much for the city. *Courtesy of the* Cincinnati Enquirer *archives.*

When he was nineteen, Hearn was given one-way passage to America to meet a family acquaintance in Cincinnati. After slumming in New York for months, he made it to Cincinnati in 1870 but was turned away by his local contact. Penniless and homeless, he slept in warehouses and haylofts, scrounging to survive. He worked as a proofreader for the publisher Robert Clarke Co., where he earned the nickname "Old Semicolon" for his persnickety attention to grammar, and he served as private secretary to Thomas Vickers, the future librarian of Cincinnati's public library.

Though sharp and inquisitive, Hearn was self-conscious about his appearance. He was a gnomish man with an olive complexion, dark hair and moustache and bulbous, myopic eyes hidden behind thick bottle glasses. His left eye was blinded in a playground mishap as a child when a rope struck him, leaving the eye covered in a pearlescent film. Throughout his life he insisted on being photographed in profile to hide the eye.

Early in 1872, Hearn walked into the offices of the *Cincinnati Enquirer* to inquire about submitting articles. The managing editor, Colonel John A. Cockerill, who would go on to be Joseph Pulitzer's top editor at the *New York World*, recalled Hearn as "a quaint, dark-skinned little fellow, strangely diffident, wearing glasses of great magnifying power, and bearing with him evidence that Fortune and he were scarce on nodding terms."[94] Hearn offered a manuscript and fled, and when Cockerill read it later that day, he was astonished to find it charming and full of ideas.

Hearn's first article appeared on November 4, 1872.[95] His prodigious output filled the pages of the *Enquirer*, all unsigned, which was common practice at the time, but he quickly obtained a reputation for extraordinary stories about the most lurid and unseemly of topics. In his spare time, Hearn translated French works, which colored his lyric descriptions. He utilized

narrative techniques such as recording dialogue and placing himself in his stories in the third person as the Reporter. Hearn shone his journalistic spotlight in the dark corners that most people ignored or wished would remain hidden. He went to the slums of Bucktown and Rat Row to talk to the people, to the African American stevedores working on the landing, the prostitutes and the gravediggers. He wrote of abortionists and mediums with humanizing details. He wrote of ghosts and the grizzliest murders—and the city devoured every last word. Hearn offered the best description of himself:

> *Now in those days there was a young man connected with the* Daily Enquirer *whose tastes were whimsically grotesque and arabesque. He was by nature a fervent admirer of extremes.*
>
> *He believed only in the Revoltingly Horrible or the Excruciatingly Beautiful. He worshipped the French school of sensation, and reveled in thrusting a reeking mixture of bones, blood and hair under people's noses at breakfast time.*[96]

His sensational, vivid coverage of the gruesome Tanyard Murder churned stomachs and boosted circulation—and gave him his best exposure. Herman Schilling, a tanner, had been caught in a compromising position with the fifteen-year-old daughter of Andreas Egner, who swore revenge after the girl died while seven months pregnant. On November 7, 1874, Egner and his son, Frederick, along with George Rufer, who also had a quarrel with Schilling, accosted Schilling in the tanyard, beat him, stabbed him with a pitchfork and burned him alive in the furnace. Hearn aired every salacious detail and enlisted his artist friends Henry Farny and Frank Duveneck, both of whom would go on to be world-renowned painters, to draw the accompanying illustrations. Hearn himself drew the remains. But it was Hearn's visceral descriptions that really placed the reader at the scene:

THE HIDEOUS MASS OF REEKING CINDERS

Despite all the efforts of the brutal murderers to hide their ghastly crime, remain sufficiently intact to bear frightful witness against them.

On lifting the coffin-lid a powerful and penetrating odor, strongly resembling the smell of burnt beef, yet heavier and fouler, filled the room and almost sickened the spectators. But the sight of the black remains was far more sickening. Laid upon the clean white lining of the coffin they rather resembled great shapeless lumps of half-burnt bituminous coal than aught else at the first hurried glance; and only a closer investigation could enable

Three world-renowned talents—Lafcadio Hearn, Henry Farny and Frank Duveneck—worked on the *Cincinnati Enquirer*'s coverage of the Tanyard Murder in 1874. *Courtesy of the* Cincinnati Enquirer.

a strong-stomached observer to detect their ghastly character—masses of crumbling human bones, strung together by half-burnt sinews, or glued one upon another by a hideous adhesion of half-molten flesh, boiled brains and jellied blood mingled with coal. The

SKULL HAD BURST LIKE A SHELL

In the fierce furnace-heat; and the whole upper portion seemed as though it had been blown out by the steam from the boiling and bubbling brains. Only the posterior portion of the occipital and parietal bones, the inferior and superior maxillary, and some of the face-bones remained—the upper portions of the skull bones being jagged, burnt brown in some spots, and in others charred to black ashes. The brain had all boiled away, save a small wasted lump at the base of the skull about the size of a lemon. It was

crisped and still warm to the touch. On pushing the finger through the crisp, the interior felt about the consistency of banana fruit, and the yellow fibers seemed to writhe like worms in the Coroner's hands. The eyes were cooked to bubbled crisps in the blackened sockets, and the bones of the nose were gone, leaving a hideous hole.[97]

Hearn and Farny also collaborated on a satirical newspaper, *Ye Giglampz*, described as "a weekly illustrated journal devoted to art, literature and satire."[98] It ran for only nine weeks, from June to August 1874.

Hearn's unconventional lifestyle came to haunt him when his marriage to Althea "Mattie" Foley, the mixed-race cook in the boardinghouse where he lived, was exposed. Not only was marriage to a black woman scandalous, but it was also illegal in Ohio. He was fired from the *Enquirer* in 1875. Ironically, the couple had already separated, and the marriage was never legal. Hearn then wrote for the *Commercial* for a few years, including a famous piece about climbing the steeple of St. Peter in Chains Cathedral to view the city from on high (a comical tale, considering the myopic Hearn couldn't see anything while up there).[99]

Hearn tired of Cincinnati and in 1877 headed south to New Orleans, where he once again immersed himself in the varied offerings of the city, exploring Creole culture and voodoo, leading one historian to label him "the man who invented New Orleans."[100] He took writing assignments in Martinique and then went to Japan in 1890, where he settled for the remainder of his life. He worked as a teacher and wrote of Japanese folklore and ghost stories, sharing the Eastern tales with the Western world. Hearn married Setsu Koizumi in 1891, and he took a Japanese name, Koizumi Yakumo, meaning "Eight Clouds." Hearn died on September 19, 1904, and is buried in Zōshigaya Cemetery in Tokyo, where his grave bears his Japanese name. His home in Matsue, Japan, has been turned into a museum. His writings of folklore are read in Japanese schools. Yet in America, he's a ghost.

Lafcadio Hearn and Henry Farny published the weekly satire *Ye Giglampz. From the Collection of the Public Library of Cincinnati and Hamilton County/Henry Farny.*

THE LEGEND OF ANNIE OAKLEY

The image of Annie Oakley as the cowgirl sharpshooter known as "Little Sure Shot" is, like many tales of the Old West, a jumble of truth and legend. Some of the details of her life are a muddle. Despite her reputation, the Ohio native had never even been out West before she joined Buffalo Bill's Wild West show. Annie herself often fudged dates; whether it was to make her seem younger or to hide some fact she didn't want known is unclear. Perhaps it is just part and parcel of the showbiz life. One thing that was genuine, however, was her expert marksmanship.

Annie had many Queen City connections, most famously the shooting contest in which she bested her future husband, Frank Butler, as dramatized in the Irving Berlin musical *Annie Get Your Gun*. The contest is said to have taken place in Cincinnati, though the story was never recorded at the time, confounding historians. In fact, piecing together an accurate portrait of Annie's life is a challenge because of missing documentation and conflicting dates. Of the many biographies on her, *Annie Oakley* by Shirl Kasper is the most thorough in examining records and Annie's own scrapbooks.

Even the facts of her birth are unclear. Annie was born near North Star in Darke County, Ohio, about ninety-five miles north of Cincinnati. Her given name was Phoebe Ann Mosey, or Moses. Several spelling variations were used in records, and Annie preferred Mozee, spelled just as it sounds. Everyone called her Annie. The birth date listed on her death certificate is August 13, 1860, though Annie insisted it was 1866, perhaps to shave off

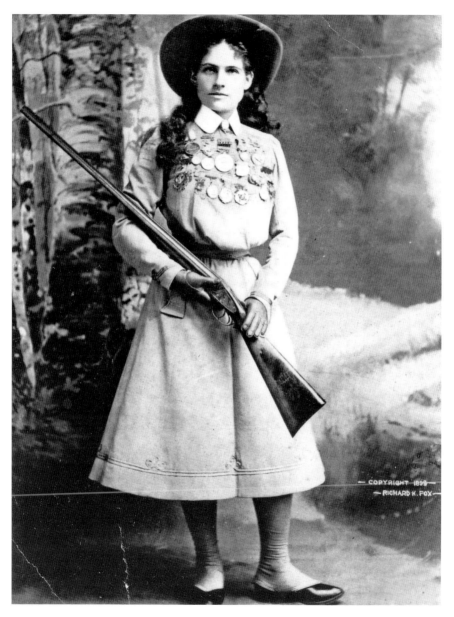

Annie Oakley, known as Little Sure Shot, won numerous medals for her sharpshooting, but separating fact from lore is rather hit or miss. *Courtesy of the* Cincinnati Enquirer *archives/ Richard K. Fox.*

some years during her show-business career. The courthouse records were destroyed in a fire in 1867.

Her parents were Quakers; though pacifists, they did use guns for hunting. To help her family make ends meet, Annie, already a proficient shooter, hunted game for shopkeeper Charles Katzenberger at the G.A. Katzenberger & Bro. general store in nearby Greenville. He then sold the birds to Cincinnati hotels, including the Bevis House, run by J.B. "Jack" Frost. Hotels allegedly liked the birds she supplied because, whereas patrons were accustomed to picking buckshot out of their meals, Annie downed quail with a single shot in the head.

Part of Annie Oakley's appeal was the contradiction of her as "a sweet little girl—yet a sharpshooter of matchless ability."[101] That is evident in her shooting contest against Butler. The legend of the contest, as it appears in most Oakley biographies, is based largely on Annie's autobiography, "The Story of My Life," which was serialized in newspapers shortly after her death.

As the story goes, the hotelier Frost suggested a fifty-dollar bet pitting his unknown shooter against Frank Butler, a sharpshooter headlining at the Coliseum Opera House at 437 Vine Street (now 1221 Vine Street, a parking lot) in Over-the-Rhine. Butler agreed. According to legend, the contest was held on Thanksgiving Day in 1875, though Annie supplied no date in her own account.

"The ground had been picked two miles out of Fairmount," Annie wrote. "My eldest sister lived there, and mother and I went there to stay. I saw a real city then for the first time."[102] The location of the contest is thought to be the Schuetzenbuckel, or Shooter's Hill, a hilltop where there was a shooting club. The area is now St. Clair Heights Park in North Fairmount, where a sign marks the historic site of the shootout.

Butler was startled to find that his opponent was a fifteen-year-old country girl. He won the coin toss and went first, firing on live pigeons released from traps. "We used two traps, gun below the elbow, one barrel to be used," Annie wrote. "I shot a muzzle-loader, but it was a good one.…The scores kept even. Mr. Butler's 25th…fell dead about two feet beyond the boundary line." (Other accounts say he missed.) "I had to score my last bird to win. I stopped for an instant before I lined my gun. I saw my mother's and auntie's face. I knew I would win!"[103]

Kasper calls that "pure fiction."[104] She sides with Butler's version of the story, told in interviews in 1903 and 1924.[105] He said the contest was in the spring of 1881, about eighteen miles from Greenville, which could have been North Star. "She licked me fairly and squarely," Butler said. "I was

SCANNELL & MISSIMER, 28 Arcade, Cincinnati, O. SCANNELL & MISSIMER, 28 Arcade, Cincinnati, O.

Legend has it that Annie Oakley first met and bested her future husband, Frank Butler, in a shooting contest held in Cincinnati. *Courtesy of Heritage Auctions.*

amazed—and fascinated. Well, I fell in love with her—and a year later we were married."[106]

Annie's autobiography has them married on August 23, 1876, one year after the traditional date of the contest. There is no marriage certificate. According to Kasper, Annie gave her niece Bonnie Patterson Blakeley a marriage certificate for Frank Butler and Annie Moses, dated June 20, 1882, in Windsor, Ontario, Canada.[107] We can only conjecture the reason for the discrepancy in dates. Butler had been married previously, but it is unknown when the divorce was finalized. Perhaps the couple was trying to obscure details if they were together before they were married.

All of these questions of places and dates make it difficult to know what really happened. So, where and when was the contest held? Did it even occur at all?

There is no concrete proof that it did; especially worrisome is the lack of contemporaneous accounts. Like many aspects of Annie's life, there is little documentation and many contradictions. Some pieces of Annie's story fit, and others don't.

The correct date for the meeting of Annie Oakley and Frank Butler is most likely 1881. Research of census records, city directories and newspapers reveal a few facts related to Annie's tale:

• Butler first appeared in the *Cincinnati Enquirer* in 1880 as part of the sharpshooter act Baughman & Butler,[108] performing at the Coliseum in 1881.[109] Later that year they signed with the Sells Brothers' Circus.[110]

• Annie's sister Lydia married Joseph Stein in 1877, and he first shows up in the Cincinnati city directory in 1880, living in Fairmount.[111]

• Jack Frost took over the Bevis House at Court and Walnut Streets in 1878.[112]

• The 1881 city directory lists a shooting gallery at the same address as the Coliseum, where Butler worked.[113] Could the shooting contest actually have been held there as a less public spectacle, which may account for the lack of news coverage of the event? Also, the Coliseum is less than three miles from Fairmount (Annie said the site was two miles away), while the Schuetzenbuckel was actually in Fairmount.

So, some details of the Cincinnati version of the story do check out, but only if the date is 1881, making Annie twenty-one years old instead of fifteen. The marriage date of 1882 then seems to work.

Another mystery is the origin of the stage name Annie Oakley, which was never recorded. Some sources suggest a link to the Cincinnati neighborhood of Oakley, that perhaps Annie and Frank resided there for a time during the 1870s. But there is nothing to indicate they lived there, and it is apparent that they didn't meet until 1881. The next year, Annie was traveling with Butler's act on tour and soon joined her husband on stage, insisting on shooting as well. The Oakley and Butler act toured with the Sells Brothers' Circus, but Annie was such a draw herself that Butler eventually stepped aside and became her manager.

In April 1885, Annie spent a month in Cincinnati practicing shooting clay pigeons before she joined Buffalo Bill Cody in Louisville. At this time in Cincinnati, Annie reportedly attempted an endurance record of shooting at 5,000 glass balls tossed from three traps over a nine-hour period. She hit 4,772 balls. Again, no contemporaneous reports have been found, though the feat was listed among her records in the Buffalo Bill programs. Kasper

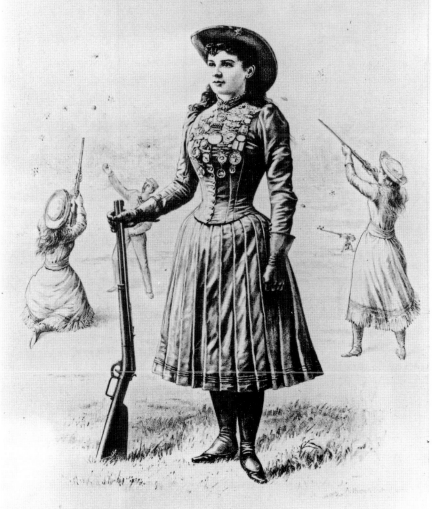

A poster for Buffalo Bill's Wild West show highlights Annie Oakley's shooting prowess. *Courtesy of the* Cincinnati Enquirer *archives.*

noted, "It was an endurance feat to be proud of, and it is curious that Annie never talked about it much, though it commonly was listed among her records."[114] Annie did not include it in her autobiography. She did write of a related incident at the time. A Cincinnati clay target vendor, not knowing her as Mrs. Butler, confided that he was selling overburned clays to Annie Oakley. She proceeded to demonstrate her shooting prowess and then revealed who she was. From then on, she got the best clays.[115]

Annie toured the world with Buffalo Bill's Wild West show for seventeen years, astounding audiences and royalty alike with trick shots, such as sighting with a mirror to shoot over her shoulder or shooting glass balls while standing on the back of a galloping horse. In 1884, Annie so impressed Chief Sitting Bull, then a prisoner of war for the massacre of General George Armstrong Custer at the Battle of Little Bighorn, that he adopted her into the Lakota tribe, christening her Watanya Cicilla, or "Little Sure Shot."

At the start of January 1891, newspapers reported the death of Annie Oakley based on erroneous cablegrams from Buenos Aires. The *Cincinnati Enquirer*'s headline, "Poor Anne Oakley…Dies in a Far-Off Land—The Greatest of Female Shots,"[116] reached her mother in North Star, and she cried for two days until a letter from Frank Butler set the record straight. Ten days later, the newspaper corrected: "Miss Oakley is reported as being alive and well and completely satisfied with her obituary."[117]

Long after Annie's retirement from show business, the Butlers moved to Dayton, Ohio, and then returned to Annie's childhood hometown in Darke County, where she died on November 3, 1926. Frank Butler died eighteen days later. Annie's body was sent to Cincinnati for cremation, and her ashes were placed in a trophy cup she had won. The remains of the couple are buried in Brock Cemetery near Greenville, Ohio, off the beaten path along U.S. 127, known around there as Annie Oakley Memorial Pike.

The legend of Annie Oakley is still alive, even if the image does not exactly match what happened. As the newspaperman said in *The Man Who Shot Liberty Valance*: "When the legend becomes fact, print the legend."

THE ECLECTIC JOHN URI LLOYD

The word *eclectic* applies doubly in describing John Uri Lloyd. In pharmaceuticals, Lloyd was the last prominent eclectic, part of a movement of "reform medicine" that was open to alternatives, particularly botanical remedies, to what they considered harsh conventional medical treatments. Lloyd was also eclectic as defined by his diverse interests and accomplishments as a pharmaceutical chemist, inventor, scholar and novelist.

Lloyd biographer Michael A. Flannery identified that what drove Lloyd was his striving for respectability.[118] This was evident in his push for eclecticism to gain more mainstream acceptance, which earned Lloyd the title "wizard of American plant pharmacy and chemistry,"[119] even as eclecticism faded away around the time of his death. The resurgence of homeopathy and, in particular, the tremendous research materials collected by the Lloyd brothers for the Lloyd Library in Cincinnati, have made his work still relevant. Yet even in Cincinnati, once the center of eclectic medicine and home to the preeminent Eclectic Medical Institute, neither Lloyd nor the eclectics are much remembered.

John Uri Lloyd was born on April 19, 1849, in West Bloomfield, New York, the firstborn son of a civil engineer and a schoolteacher, who emphasized education in the Lloyd family. In 1853, they moved to northern Kentucky, where John's father worked on a survey team for a proposed railroad. The family hopped from Florence to Crittenden. John would later capture his childhood in his Stringtown novels. John demonstrated an interest in pharmacy at an early age, substituting an ink bottle and his mother's glass

Pharmacist John Uri Lloyd excelled in several fields as an accomplished chemist, inventor and author. *Courtesy of the* Cincinnati Enquirer *archives.*

camphor bottle for flasks and pumpkin vines for tubing. When he was fourteen, John accompanied his father into Cincinnati each week to inquire of pharmacies if they needed an assistant. He found an apprenticeship with W.J.M. Gordon & Brother, where John learned the ropes of the pharmacy

business, from how to use tables for weights and measures to mixing prescriptions and tinctures. After four years as an apprentice, John became a clerk and quickly gained the notice of the eclectic movement.

Eclectic medicine evolved as a reaction to the abrasive effects of conventional medicine in the mid-nineteenth century, particularly the practices of bleeding and administering massive doses of calomel, which contains mercury. Eclectic pharmacists instead derived drugs from plants and were consequently ostracized by the regular profession. The eclectic movement, influential for nearly a century, created its own educational institutions. The Eclectic Medical Institute, at the northwest corner of Plum and Court Streets, was chartered in Cincinnati in 1845 and grew to become the premier eclectic college in the country. Noted eclectics John King and John Milton Scudder recruited Lloyd to join H.M. Merrell's pharmacy, a decision that forever allied Lloyd with the eclectics.

In 1877, Lloyd and his brother Nelson Ashley Lloyd, known as Ashley, became partners in Merrell, Thorp & Lloyd and then split off in 1885 as Lloyd Brothers, which then included a third brother, Curtis Gates Lloyd. John, the eldest, was the visionary chemist, while Ashley handled the business interests and Curtis, a botanist, specialized in fungi. The Lloyd Brothers was small but successful as a manufacturer of Special Medicines, the strongest extract from particular plants, produced for a niche market of eclectic physicians. John's patented pharmaceutical inventions included a curved medicine dropper and a cold still extractor that extracted a plant's chemical components without applying heat, which altered the chemical properties.

As a scholar, John contributed to numerous journals and was a teacher at the Eclectic Medical Institute and the Cincinnati College of Pharmacy. His troves of books and journals, from the arcane to the complete runs of eclectic journals, expanded to thousands of volumes. Along with Curtis's extensive collection of botany books on mycology, the study of fungi, the brothers built a library at 224 West Court Street in 1902, but the collection quickly outgrew the space. A new four-story building was erected in 1908 at 309 West Court Street, housing 98,000 volumes. Long after the brothers were gone, the current Lloyd Library and Museum was constructed in 1970 at 917 Plum Street on the same lot. It is one of the largest pharmaceutical libraries in the country, holding more than 200,000 volumes, including the collection of the Eclectric Medical College, which closed in 1939.

Just as intriguing as Lloyd's place in the pantheon of pharmacy are his varied contributions to literature. The thin, proper scientist had a fanciful side, expressed in his writing. The majority of his fiction writings were

THE ECLECTIC MEDICAL INSTITUTE.

The Eclectic Medical Institute at Plum and Court Streets was the premier college of the eclectic pharmacy movement in the country. *From* Illustrated Cincinnati.

quaint, local color tales set in a fictional Kentucky town, Stringtown, a stand-in for Florence, where he spent his youth. He wrote six novels in the series, starting with *Stringtown on the Pike*. To contemporary audiences, the novels are hindered by distracting colloquial dialect and racial stereotypes, although he effectively chronicled Civil War–era Kentucky.

The Stringtown novels were a far cry from Lloyd's first literary offering, *Etidorhpa; or, The End of Earth*, a quixotic novel that defies categorization, running the gamut from occult to utopian to science fiction and even psychedelic. The lengthy subtitle, starting with *The Strange History of a Mysterious Being and the Account of a Remarkable Journey...*, indicates the book is a manuscript recorded by Llewellyn Drury and only published by Lloyd. The plot, briefly, has Drury, of Cincinnati, visited by a mysterious bearded stranger known as I—Am—The—Man, who tells his tales to Drury under the promise that he wait thirty years and then publish the manuscript (which, instead, was left for Lloyd to do). In the stranger's recounting, he had been kidnapped and prematurely aged, then met a naked human figure with skin like blue putty who guided him underground into the hollow Earth. There, he undergoes trials in which the fantastical is possible in order to reach the "Unknown Country," the land of the divine being Etidorhpa (Aphrodite spelled backward) at the end of the earth.

Published in 1895 in a small print run sold to Lloyd's friends, *Etidorhpa* became a big seller, despite no one really knowing what to make of it. Its ties to Lewis Carroll and Jules Verne are clear, and H.P. Lovecraft was a fan. But occultists took the book as truth, misunderstanding the literary device of presenting the novel as a found document, as had been done with *Don Quixote*, *Gulliver's Travels* and others, to give the story verisimilitude. That opinion was prevalent. Cincinnati chronicler Charles Frederic Goss, a contemporary of Lloyd, called *Etidorhpa* "one of the most striking revelations from the occult world";[120] occultists have kept the novel in print for more than 120 years. Other critics have latched on to the novel's Wonderland-esque adventures as proof,

An illustration from John Uri Lloyd's novel *Etidorhpa* portrays a phantasmagoric passage through a forest of giant fungi. *From* Etidorhpa/*J. Augustus Knapp.*

without actual evidence, that Lloyd must have been partaking of his own pharmaceuticals. His biographer Flannery, the former director of the Lloyd Library, refutes such interpretation and cites an unpublished statement kept in the library files in which Lloyd tried to set the record straight that the book was fiction and the hallucinogenic portions were added to demonstrate the dangers of abusing chemical substances. The novel represented Lloyd's opposition to the hubris of scientism, the excessive belief in the absolute proof of scientific knowledge at that time.[121]

Lloyd passed away on April 9, 1936, while visiting his daughter in Van Nuys, California. His home, at the bend of Clifton Avenue in Clifton, was designed by famed Cincinnati architect James W. McLaughlin and is listed in the National Register of Historic Places. A plaque in Norwood, where Lloyd lived for many years, marks his accomplishments and impact on the community. The Lloyd Library continues Lloyd's legacy. It is a respected resource for those seeking alternative medicines. But to most people, Lloyd remains a figure on the margins.

An Ovation for Cora Dow

Cora Dow wanted to sing opera. Throughout her life, she was passionate for beautiful music and aspired to perform Wagner on the stage, but she gave up her dream to help in her father's drugstore. She ended up turning Dow's Drugs into the second-largest chain of pharmacies in the nation. Her success as an entrepreneur is all the more remarkable considering that Dow lived in the late nineteenth century, a time when female pharmacists and female business leaders were exceptionally rare.

She was born on March 11, 1868, in Paterson, New Jersey, as Martha Cornelius Dow. The family moved to Cincinnati when Cora was two years old, and her father, Edwin Dow, peddled medicine with young Cora tagging along. He opened a drugstore, a cramped little shop at 545 West Fifth Street, with the family living above it. When her father became ill, as the only child, she stepped in to assist and ended up taking over the store in 1885. She became only the second woman to graduate from the Cincinnati College of Pharmacy, at Fifth and John Streets (west of Central Avenue). "Frankly, I did not yearn a lot for pharmacy," Dow said. "I did want grand opera, and had an ambition to stand behind the footlights and pour forth volumes of melody to delighted audiences. But there was the matter of bread-winning, and so I studied pharmacy and powders and pills."[122]

Pharmacies were found on every corner in those days, each a separate company with an in-house pharmacist. Dow was more than capable of competing, and within a few years of taking over the business, she added more stores, capitalizing on the bustling intersections near train depots and

Cora Dow made huge strides for women in business and in pharmacy with her incredible success developing a chain of drugstores. *Courtesy of the Library of Congress/Bain News Service*

theaters, at Fountain Square, one of the busiest corners in the United States, and at Peebles' Corner in Walnut Hills. When she sold the company in 1915, Dow's Drugs had eleven stores, fewer than Liggett's (forty-five) and more than Walgreens (nine).

What made her stores stand out were Dow's unconventional practices for that time. She catered her stores to appeal to more "feminine desires and prejudices,"[123] figuring that would attract female customers. She hired as many female pharmacists as she did men, and offered equal pay for equal work. In her essay "Women as Pharmacists," Dow ruminated on her views on what women brought to the profession. "Strictly temperate habits, in order that the brain may be active and alert at all times, and a cheerful disposition, are qualities in which women have the advantage."[124] Dow also noted, "That women should prefer to purchase drugs and consult with one of their own sex on matters which have interest for them alone, is the most natural thing in the world."[125]

She offered cut-rate discounts below retail costs on medicines, banking on customers attracted by the lower prices buying additional items. That practice would later make Walmart a commercial empire, but it was uncommon in the 1890s. The druggists felt threatened. Wholesalers and manufacturers blacklisted Dow, making it more difficult for her to obtain medicines. "So we were sued, blacklisted, damned, ignored, hounded, threatened, boycotted, attacked, slandered, followed by detectives, sentenced to jail once upon a time, and hated with all of the concentrated hate that little minds can store up," Dow recalled.[126] She sued the wholesalers and manufactures to keep them from setting a price on medicines, but when she wouldn't testify who was secretly providing her with products, she was jailed for contempt and released on bail. She ultimately prevailed in court, setting the precedent of allowing retailers to set prices.

Dow's Drugs store at Fourth and Main Streets was one of eleven pharmacies owned by Cora Dow, each in a high-traffic area of the city. *Courtesy of the* Cincinnati Enquirer/*Lawrence J. Neumann.*

By all accounts Dow was an attentive owner, visiting each store every day, and was well liked by her employees. She adored animals and campaigned for mandatory rest for workhorses. Despite being progressive in matters of business, Dow did not support women's suffrage. "No woman needs to vote, and no woman needs to insist on her rights," Dow said, adding, "I'm a bit old-fashioned on the whole question of women in business. I like the old-time idea best, where women were the idol of the home and the men went out into the world."[127] That goes to show the uphill climb women faced.

When Dow became ill, she determined that she couldn't oversee the stores. She sold the Dow Drug Company to investors from Cincinnati and Cleveland a few weeks before her death. Under the new owners, the Dow chain expanded to sixty stores by 1931, but the last one closed in 1961.

Cora Dow died of tuberculosis on October 17, 1915, and is buried in Spring Grove Cemetery. The trade publication *Pharmaceutical Era* memorialized her: "Miss Dow was credited with being a woman of more than average ability,

a natural aptitude for business and was an indefatigable worker....In many ways she was a remarkable woman."[128]

An event was held in her honor at Music Hall on January 5, 1916. Former president William Howard Taft offered an elegant tribute:

> *The woman whose good work we celebrate was not one who had inherited her wealth, not one to whom it had come by lucky chance or fortunate speculation. She was not one to whom success was an accident. She was a woman who was a master of her fate, whom from early life laid down and adopted, as a means of achieving usefulness for herself and her kind, a plan of life and a plan of action which she maintained until her death, with extraordinary consistency and strength of character.[129]*

Taft added, "Among all philanthropists I have heard of, Cora Dow was most exceptional."[130] Dow willed money to her mother, her employees, orphanages, and the Ohio Humane Society, but she never forgot her heart. For a finale, she bequeathed most of her estate, $700,000 ($16.5 million in 2016), as an endowment fund to the Cincinnati Symphony Orchestra. Dow fulfilled her dream of making music. Taft shared her wish: "If I can be instrumental in giving to Cincinnati the finest orchestral music in this country I ask no better heaven."[131]

Brava!

MARTHA, THE LAST PASSENGER PIGEON

O n the afternoon of September 1, 1914, at about 1:00 p.m., the last passenger pigeon on Earth died at the Cincinnati Zoological Garden. Her name was Martha. She was a rather typical representative of her species, a handsome bird of blue and beige plumage, made remarkable for being the last of her kind.

The extinction of the species is tragic, but not surprising, considering the rampant hunting of the birds and careless disregard for their proliferation. What is unfathomable is how abundant the passenger pigeons were and yet how quickly they were wiped out. Naturalist A.W. Schorger estimated that at the time European settlers started pouring into the continent, passenger pigeons constituted about 25 to 40 percent of the total bird population in North America.[132]

Ectopistes migratorius, also known as the wild pigeon, was one and a half times the size of a mourning dove, fifteen to eighteen inches in length, weighing ten to twelve ounces. The male was colored slate blue with the throat and breast in ruddy copper that seemed iridescent around the neck. The wings were flecked and tipped with black feathers. The female passenger pigeon was duller in appearance, with drab beige rather than copper. The pigeons ate fruits, seeds and nuts, and they were partial to beechnuts. It is generally accepted that they laid one egg at a time, but early naturalists sometimes reported two. Because they were rarely studied before they went extinct, and almost no scientific study of them was conducted in the wild, there are many questions about the species.

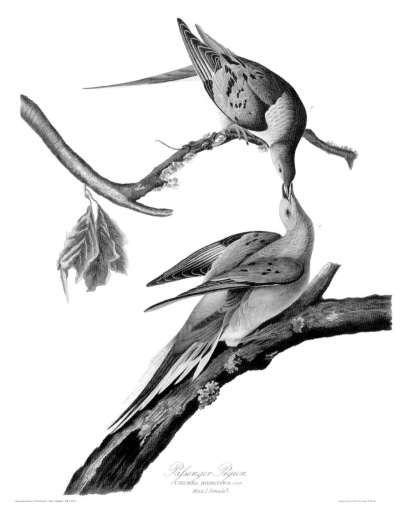

John James Audubon illustrated the male and female passenger pigeons in his famous book *The Birds of America. Courtesy of the National Audubon Society/John James Audubon.*

Passenger pigeons were so named for being wanderers, never staying too long in one place. The range of the pigeons was the eastern and midwestern United States and Canada, and their migratory flights were remarkable sights. John James Audubon, the famed naturalist painter of *The Birds of America*, wrote of such a flight that he encountered in the autumn of 1813, along the banks of the Ohio River near Louisville, Kentucky: "The air was literally filled with pigeons; the light of noon-day became dim, as during

an eclipse; the pigeon's dung fell in spots, not unlike melting flakes of snow; and the continued buz of their wings over me, had a tendency to incline my senses to repose."[133] The pigeons flew continuously overhead for three days, Audubon wrote. Major W. Ross King, an English hunter and naturalist, wrote of witnessing an enormous migration of passenger pigeons at Fort Mississauga on Lake Ontario about 1860:

> *Early in the morning I was apprised by my servant that an extraordinary flock of birds was passing over, such as he had never seen before. Hurrying out and ascending the grassy ramparts, I was perfectly amazed to behold the air filled and the sun obscured by millions of pigeons, not hovering about, but darting onwards in a straight line with arrowy flight, in a vast mass a mile or more in breadth, and stretching before and behind as far as the eye could reach.*
>
> *Swiftly and steadily the column passed over with a rushing sound, and for hours continued in undiminished myriads advancing over the American forests in the eastern horizon, as the myriads that has passed were lost in the western sky.*
>
> *It was late in the afternoon before any decrease in the mass was perceptible, but they became gradually less dense as the day drew to a close.*[134]

King calculated the duration of the flight at fourteen hours, with a column one mile wide and three hundred miles in length. Using King's observations, Schorger calculated the number of pigeons in the flight at 3.7 billion—*one migratory flight.*[135] While nesting, it was not uncommon for the sheer number of pigeons on a tree to bend the tree's limbs to the ground.

So, what happened? For generations, passenger pigeons were so plentiful that it seemed impossible for them to be endangered. They filled the skies like clouds and became easy targets for hunters. Dozens could be downed in a single shot, and the birds flew so low that kids could hit them with rocks and sticks. Passenger pigeons were hunted endlessly as a source of cheap food, sold a penny apiece. Railroads shipped pigeon meat across the country, creating more demand. Large nets were set up to trap birds lured in by a captive pigeon, often with its eyes sewn shut to not be distracted, sitting on a stool (the origin of the term "stool pigeon," meaning someone who betrays his colleagues). Netting would nab fifty dozen or more birds at a time. Pigeons were so common that they were used as targets in trap shooting. The first shooting club in the country started in Cincinnati sometime in the 1820s, and the first trapshooting competition, using live birds as targets, was

held by the Sportsmen's Club in Cincinnati in 1831. Coincidentally, in 1880, George Ligowsky of Cincinnati invented the clay pigeon to replace the glass balls and live birds in trap shooting.

This "wholesale slaughter"[136] devastated the passenger pigeon population, and by 1890, thirty years after King descried billions, the population had dwindled to several thousand. Attempts at conservation and protection laws came too late. Three captive flocks of passenger pigeons were kept in hopes of saving and breeding them, but there were too few birds left. David Whittaker started a small aviary of passenger pigeons in Milwaukee, Wisconsin, in 1888 that grew to fifteen pigeons. Some were sold to biologist Charles Otis Whitman in Chicago, who kept a flock of sixteen. The birds all died or escaped, though Whitman sold one hen to the Cincinnati Zoological Garden in 1902.

The zoo, when it opened in 1875, housed several passenger pigeons in Japanese-style aviary buildings designed by Cincinnati architect James W. McLaughlin. The history of the zoo's pigeons is "hopelessly confused,"[137] in

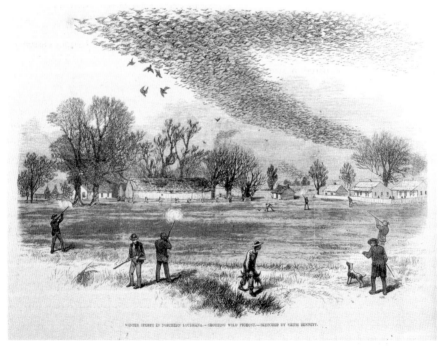

A sketch of shooting wild pigeons in northern Louisiana from 1875 depicts both how plentiful passenger pigeons were at the time and how casual was the hunting of them, which led to the birds' extinction. *From* The Illustrated Sporting and Dramatic News/*Smith Bennett.*

part because zoo superintendent Sol Stephan, a former circus-elephant handler, wasn't an academic zoologist and didn't seem concerned about consistency in his reports. Stephan alternately claimed that the hen was from the Whitman flock and that it was born at the zoo, or that she was named after Martha Washington or for the wife of a friend. Martha was born sometime between 1888 and 1902, depending on the report. Upon her death in 1914, Stephan claimed in news accounts that she was twenty-nine years old,[138] a remarkably old age for a pigeon. A 1968 memo from zoo director Ed Maruska admits that Martha's "history is shrouded by inaccurate reports as to her longevity," noting that "doves and pigeons normally have a lifespan of thirteen to fifteen years. It would be difficult to believe Martha lived to be twenty-nine."[139]

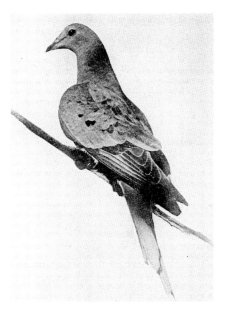

Martha, the last passenger pigeon, was photographed at the Cincinnati Zoological Garden about 1912. *From* Published Figures and Plates of the Extinct Passenger Pigeon/*Enno Meyer.*

As with the other captive flocks, attempts at breeding were unsuccessful. Martha's cage-mate, George—the last male passenger pigeon—died on July 10, 1910. An offer of $1,000 for a nesting pair of pigeons or a mate for Martha found no takers, indicating that Martha was truly the last.

Crowds came to catch a glimpse of the old and frail pigeon, who sat on a perch lowered close to the ground and hardly moved. When Martha died in 1914, the passenger pigeon was extinct. She had been molting when she died, but her feathers were saved and reattached after death. Her body, promised to the Smithsonian Institution, was frozen in a three-hundred-pound block of ice for the train trip to Washington, D.C. Her internal organs were preserved as part of the fluid collection of the National Museum of Natural History. Her body was skinned, stuffed and mounted, then put on display until 1999.

When the aviaries at the Cincinnati Zoo were to be torn down in the 1970s, Cincinnati artist John A. Ruthven, "the twentieth-century Audubon," led efforts to retain the building in which Martha had lived and died. It was

remodeled as the Passenger Pigeon Memorial building, and a statue was installed. Martha's remains made the trip back to Cincinnati in June 1974 for the fundraiser kickoff. In 2013, to commemorate the 100th anniversary of Martha's passing, Ruthven painted an homage, *Martha, the Last Passenger Pigeon*, which ArtWorks re-created on a wall at Eighth and Vine Streets. In the painting and mural, Martha leads a flock of passenger pigeons flying off into history.

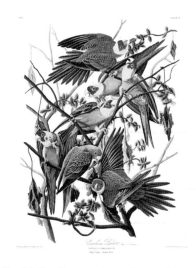

Playful Carolina parakeets, depicted in Audubon's *The Birds of America*, are also extinct. The last Carolina parakeet died in the same aviary as the last passenger pigeon. *Courtesy of the National Audubon Society/John James Audubon.*

CAROLINA PARAKEET

Four years after the passing of Martha, the Cincinnati Zoo was also home to the last Carolina parakeet. *Conuropsis carolinensis* was the only parrot species native to the United States. The colorful parakeet was instantly recognizable, with its bright green body, yellow head and red face. The zoo purchased several Carolina parakeets for $2.50 each in 1888, but they gradually died out. The last parakeet mates, Incas and Lady Jane, were reportedly together for thirty-two years until Lady Jane died in the summer of 1917. After that, the male Incas appeared to be grieving, and he passed away on February 21, 1918.[140] In a twist of fate, Incas, the last Carolina parakeet, died in the same aviary cage as had Martha, the last passenger pigeon.

PART IV

TWENTIETH CENTURY

An aerial view of Cincinnati, circa 1954, captures the city on the verge of midcentury urban renewal. *Courtesy of the* Cincinnati Enquirer/*Herb Heise.*

WINSOR MCCAY, MASTER OF CARTOONS

If Walt Disney is among the most influential Americans in the twentieth century, what does that say about an artist who influenced Disney? Years before Disney conquered animation, cartoonist Winsor McCay helped develop the nascent medium as the "first American animator of consequence."[141] McCay, who began his career in Cincinnati painting posters and wall signs, had already achieved even greater significance on the comics page. An innovator of comic strips and animation, he set the bar high for both.

McCay's masterpiece *Little Nemo in Slumberland* is considered "the most beautiful and innovative comic strip ever drawn."[142] McCay's imagery and artistry inspired Maurice Sendak, especially his books *In the Night Kitchen* and *Where the Wild Things Are*, and *Calvin and Hobbes* cartoonist Bill Watterson. Art Spiegelman, creator of the Pulitzer Prize–winning graphic novel *Maus*, calls McCay a genius.[143]

McCay was born Zenas Winsor McKay (with a "K"), named for family friend Zenas G. Winsor. McCay's father later changed the spelling of the family name. Where and when McCay was born is not known because of conflicting dates and a lack of documentation of his birth. Animation historian John Canemaker, who produced the authoritative biography on McCay, agrees with census records that indicate McCay was born in 1871 in Canada, where the McKays lived before immigrating to Michigan.

He grew up in Spring Lake, Michigan, where even as a child he "couldn't stop drawing anything and everything."[144] He drew everywhere—on fence

Cartoonist Winsor McCay was an innovator of comic strips with *Little Nemo in Slumberland* as well as animated films. *Courtesy of the* Cincinnati Enquirer *archives.*

posts, blackboards, even the sides of barns. He was mostly self-taught and had a talent for memory sketches and perspective.

McCay found his way to Cincinnati in 1891 to work as a painter for Kohl & Middleton's Vine Street Dime Museum, a combination of a vaudeville show and an exhibition of grotesque curiosities on the east side of Vine Street between Fifth and Sixth Streets, near Fountain Square. The building later

became the Family Theater. McCay created enormous posters promising a glimpse of attractions, and people took notice. Local sign painter Philip Morton, who hired McCay to paint wall advertisements, described the young artist at work. Always impeccably dressed in a hat and coat, McCay would "do a little jig, rolling countless cigarettes to stimulate his thought. As he jigged and hummed a little tune, McCay would start to mix his pigments and begin his sketches."[145] Passersby would marvel as McCay, only five-foot-five, would stand atop a barrel to draw an eight-foot-tall figure on a wall using one continuous line.

The *Cincinnati Commercial Tribune* hired McCay as an artist in 1898, when newspapers used illustrations rather than photographs to accompany news stories. He began selling cartoons to the humor magazine *Life* and, in 1900, hopped over to the *Cincinnati Enquirer* as an artist and head of the art department. There he developed his first comic strip.

The Tales of the Jungle Imps debuted in the *Enquirer* on January 18, 1903. McCay illustrated humorous poems by Felix Fiddle, the pseudonym of Sunday *Enquirer* editor George Randolph Chester. In the vein of Rudyard Kipling's *Just So Stories*, the cartoons explained how animals got their defining traits, like how a porcupine got his quills. The three jungle imps were tribal natives, drawn as racial stereotypes that were common in cartoons of the day, who would pester exotic animals. Monkeys would then intervene to "fix" the animals, such as adding rubber to stretch the necks of giraffes. The innovative McCay was experimenting with the comics page from the beginning. In one strip, the imps, kicked by a kangaroo, break through a panel border and crash into the letters of the title. In another, he used the three identical imps diving into water to represent three stages of the diving motion, an illusion of animation. After just forty-three weekly episodes of *Jungle Imps*, McCay was swept off to the *New York Herald*, which offered three times his salary.

McCay flourished in New York, doing illustrations and editorial cartoons as well as several newspaper strips, including *Little Sammy Sneeze* and *Dream of the Rarebit Fiend*. The latter strip featured bizarre nightmares of folks who suffered from eating Welsh rarebit, a melted cheese dish, before bedtime. It was a precursor to *Little Nemo*, exploring the dream state from an adult perspective. *Little Nemo in Slumberland* premiered in the *Herald* on October 15, 1905. Nemo, a little boy modeled after McCay's son, Robert, traveled to fantastical lands with his friends Flip and Impie, one of the jungle imps. Their adventures, marvels of color, design and imagination, brought surrealism to the funny pages decades before there was such an art movement. In one

Winsor McCay started breaking the boundaries of what is possible in comic strips with his first series, *Tales of the Jungle Imps*, as demonstrated in this strip from February 1, 1903, for the *Cincinnati Enquirer*. *Courtesy of the* Cincinnati Enquirer/*Winsor McCay.*

adventure, the legs of Nemo's bed grow longer and start walking about the cityscape, so McCay elongated the panels to stretch across the full comics page. At the end of each strip, Nemo awoke in his bed. McCay was pushing, contorting and rewriting the rules of comic design barely a decade after the form was created.

Little Nemo was phenomenally successful in the days before syndication, when comic strips appeared in only one paper, so it was inevitable that a fierce competitor like William Randolph Hearst would snatch McCay away. In 1911, he was lured to Hearst's *New York American*, where *Little Nemo* ran as *In the Land of Wonderful Dreams*.

McCay was extremely prolific, drawing multiple comic strips and editorial cartoons each week, yet he continued to expand his horizons. On vaudeville he did chalk talks, in which he drew lightning-fast chalk sketches, sometimes competing against other cartoonists. McCay and fellow Cincinnati cartoonist R.F. Outcault competed at Music Hall as part of an all-star event on May 26, 1914.

As a hobby, McCay created some of the first animated films ever made. Early animation was basically a camera trick to make simple figures move, as in his first short, *Little Nemo*, in 1911. McCay claimed to have drawn the 4,000 moving pictures for the film by himself in one month. He also invented the animation techniques of registry marks to line up the frames, and key frames, what he called the "McCay Split System," in which he drew the pivotal pictures in a sequence, then filled in the frames in between. The process is known in the industry today as "inbetweening." McCay refused to patent or copyright his animation process, believing it should be available for all, but one day, he demonstrated his process to a man claiming to be a magazine writer. A few months later, John Randolph Bray filed a patent on nearly every animation technique, including McCay's.

More than the process set McCay's work apart. For his landmark film *Gertie the Dinosaur* in 1914, he created something new: Gertie, a friendly brontosaurus, was the first animated character with a real personality. The film was originally part of McCay's vaudeville act. On stage, McCay instructed the animated Gertie on the screen to perform tricks like a trained elephant. Beyond lifting her foot or dancing on command, she shows a playful attitude and is shy, sensitive, petulant and endearing. For the finale of the act, McCay walked out of the spotlight, and an animated McCay appeared onscreen as though he had stepped into the film. He then hitched a ride in Gertie's mouth and rode off on her back.

McCay's animations were popular with audiences and peers, but not Hearst, who felt they distracted from his cartoons. Bound by a strict contract, McCay was forced to give up his performances and animations, and eventually his comic strips, to focus on editorial cartoons for the newspaper. McCay worked until his sudden death of a cerebral hemorrhage on July 26, 1934.

Winsor McCay's groundbreaking animation film *Gertie the Dinosaur*, drawn by hand on rice paper, was the first to feature an animated character with personality and emotions. *Courtesy of the Library of Congress/Winsor McCay and John A. Fitzsimmons.*

Looney Tunes animator Chuck Jones wrote, "The two most important people in animation are Winsor McCay and Walt Disney, and I'm not sure which should go first."[146] Disney included a reenactment of the "Gertie" vaudeville routine on the television show *Disneyland* in 1955.[147] During production of the reenactment, Disney gestured to his animation studio and told McCay's son, "Bob, all this should be your father's."[148] For many years, a giant figure of Gertie could be found at Disney's Hollywood Studios in Florida.

McCay's cartoons were extremely popular but ephemeral. His popularity took place in the days before television and videotape allowed older works to be experienced by later generations. His films were made on flammable nitrate, and some were lost. Few of his original drawings have been preserved. Of the 10,000 drawings for *Gertie the Dinosaur*, only about 400 still exist. The Billy Ireland Cartoon Library & Museum at Ohio State University reported that in 2006, eleven original art pages of *The Tales of the Jungle Imps* resurfaced, the only known originals of that first strip made in Cincinnati. The museum acquired five of them, adding to over ninety original McCay pieces in its collection. In the Internet age, it is possible to read McCay's comics and watch his films, but people first have to be made aware of who he is. Winsor McCay was a genius of another era.

R.F. OUTCAULT

R.F. Outcault, another early cartoonist and creator of the Yellow Kid and Buster Brown, studied art in Cincinnati before making his mark on the history of comics.

Richard Felton Outcalt was born on January 14, 1863, in Lancaster, Ohio. When his cartooning career began, he added an extra "u" to his name. Starting at age fourteen, he studied art at McMicken University's School of Design; McMicken was absorbed into the University of Cincinnati, and the design school split off as the Art Academy of Cincinnati. Outcault was drawing for the *Cincinnati Enquirer* and the local magazine *Criterion* when he did illustrations of the Edison Laboratories exhibit at the Centennial Exposition of the Ohio Valley and Central States, held in Cincinnati in 1888.[149] Thomas Edison was impressed with Outcault's drawings and hired him as a technical artist. Outcault studied art in Paris for a year, acquiring his taste for

Cartoonist R.F. Outcault is credited with the first comic strips, starring the famous Yellow Kid, and created the ever-popular Buster Brown. *Courtesy of Kevin Grace.*

wearing berets and capes, and then landed in New York and started drawing cartoons for *Truth* magazine and Joseph Pulitzer's *New York World*.

Outcault's cartoons often depicted street urchins in a New York tenement alley and, starting in February 1895, a bald-headed boy with big ears, two teeth and a kid's dress. Outcault called him Mickey Dugan, but when a printer colored his dress a distinct yellow, he became the Yellow Kid—and a worldwide sensation. As the star of Outcault's *Hogan's Alley* cartoons in the Sunday color supplement, the Yellow Kid boosted newspaper sales. The kid was soon stamped on bubblegum cards and cigarette boxes, making Outcault a pretty penny, as he had the foresight to copyright the character.

The newspaper circulation war between Pulitzer's *World* and William Randolph Hearst's *New York Journal* included pillaging the competition's talent. In October 1896, Outcault took the Yellow Kid over to the *Journal*.

The cartoon "The Yellow Kid and His New Phonograph," appearing in the *New York Journal* on October 25, 1896, is regarded by historians as the first comic strip. *From the* New York Journal/*R.F. Outcault.*

Outcault owned the character, but the *World* owned *Hogan's Alley*, which continued with another artist, and for a year, both papers ran Yellow Kid cartoons. The term "yellow journalism," criticizing the sensationalism of the two papers, has been associated with the battle over the Yellow Kid, though the term predates Outcault switching sides. The Yellow Kid's star shone brightly and briefly, and by mid-1898, just three years after his debut, the kid was gone from the comics pages altogether.

Comics historian Bill Blackbeard of the San Francisco Academy of Comic Art credited Outcault with actually inventing the comic strip, which Blackbeard defined as "a serially published, episodic, open-ended dramatic narrative or series of linked anecdotes featuring recurrent, named characters."[150] The cartoon "The Yellow Kid and His New Phonograph," appearing on October 25, 1896, was the first to carry the hallmarks of a comic strip, including Outcault's first use of word balloons. Cartoons were usually one large panel with captions printed below the frame. Other historians question that Outcault was first, but there is no doubt he was influential. Within months, other artists used the form, and the newspaper comics page was born.

In 1902, Outcault created the comic strip *Buster Brown*, about a boy in a Little Lord Fauntleroy suit and his bulldog, Tige. It went on to even greater

success. Outcault licensed his characters to the Brown Shoe Company, makers of the popular Buster Brown children's shoes and the girls' black strap shoes named for Buster's sweetheart, Mary Jane. Occasionally, a little bald boy in a yellow dress would make an appearance in the strip. Outcault died in Flushing, New York, on September 25, 1928.

These two cartoon masters left their enormous mark on the comic field and then were buried by time, celebrated by cartoonists and scholars but forgotten by the world.

The Baseball War

C incinnati has a prominent place in baseball history as the home of the first professional team, the Red Stockings (1869), and the first night game, at Crosley Field (May 24, 1935). But the city is rarely noted for its role in keeping America's pastime from breaking apart in the baseball war that threatened the game at the dawn of the modern era.

The Cincinnati Reds were one of the charter teams of the National League in 1876, but the league added rules prohibiting Sunday games and the sale of alcohol, which didn't sit well with Cincinnati's beer-loving German population. As a result, the Reds dropped out of the league in 1881. The team played in the American Association until it rejoined the National League in 1890. By then, the league had become rowdy and unruly. Cheating was rampant. Players would trip baserunners or grab their belts to hold them back. Runners would head straight home from second base when the umpire was distracted. And the fans, or "cranks," would join in, swearing purple prose to distract players and throwing beer glasses onto the field. This was the era when baseball audiences were first called "fanatics," shortened to "fans."

One man took it upon himself to clean up the game. Byron Bancroft "Ban" Johnson was born on January 6, 1864,[151] in Norwalk, Ohio, but grew up in the Cincinnati suburb of Avondale. After attending Oberlin College and Marietta College, he left the Law School of Cincinnati College in 1887 to become a sportswriter for the *Cincinnati Commercial Gazette* for twenty-five dollars a week. Johnson was a formidable man, both in size and ambition. In

Ban Johnson, who was referred to as the "czar of baseball," founded the American League and, after the major leagues merged, virtually ran the game from 1903 to 1920. *Courtesy of the Library of Congress.*

his baseball columns, he railed against the rowdiness of the game. One night, over drinks with the Ten Minute Club in the Grand Hotel at Fourth Street and Central Avenue, he and Reds manager Charles Comiskey hatched a plan for a second league to challenge the National League.

With Comiskey's endorsement, Johnson was named the president of the revamped Western League, a minor league out west. Under Johnson, teams would play a game free from the shenanigans of the National League. "My determination," Johnson said, "was to pattern baseball in this new league along the lines of scholastic [college] contests, to make ability and brains and clean, honorable play, not the swinging of clenched fists, course oaths, riots or assaults upon the umpires, decide the issue."[152] Comiskey left the Reds and bought a Western League franchise that would become the Chicago White Sox. After a few years of upstanding play, Johnson thought the time was right to really challenge the National League's monopoly. In 1900, he changed the Western League to the American League and shuffled the teams east, placing some franchises in cities with National League teams to compete for fans' attention. Johnson proclaimed, "The American League will be the principal organization of the country within a very short time. Mark my prediction!"[153] The baseball war was on.

Johnson struck first, going after the top National League stars, who were more than eager to jump to the upstart league. The National League had a reserve system that kept players locked onto their teams and salaries fixed at a maximum of $2,400. Johnson scheduled games at the same time as the crosstown rivals'. The competition was brazen and underhanded. The courts got involved in disputes between the leagues over player contracts. The biggest battle in the war started between Johnson and John McGraw, the fiery owner and manager of the AL's Baltimore Orioles. McGraw didn't conform to Johnson's cleaned-up rules of the game and frequently clashed with umpires, so Johnson suspended him indefinitely in June 1902. McGraw got even by selling his majority ownership of the Baltimore team to Reds owner John T. Brush, who had been buying up interest in the New York Giants. In exchange, McGraw was made the manager of the Giants. Brush then decimated his Baltimore team by transferring most of the players to his Cincinnati and New York squads, to the point that the Orioles had to forfeit games. Ban Johnson took over the Baltimore team, and it stumbled through the rest of the season.

Brush wanted ownership of the Giants, so on August 9, 1902, he sold the Reds for $150,000 to four partners: Cincinnati mayor Julius Fleischmann and his brother Max; George B. Cox, the infamous "Boss Cox" who ran

the Republican political machine that controlled Cincinnati; and August "Garry" Herrmann, one of Cox's lieutenants who became president of the ball club. Herrmann was born on May 3, 1859, in Cincinnati, and grew up in Over-the-Rhine. The foreman at his first job gave him the nickname Garibaldi, which was shortened to Garry. In the 1891 city election, Herrmann had thrown in with Cox's candidate, and the political go-getter rose within Boss Cox's machine. Herrmann was appointed to the board of administration and the Cincinnati Waterworks Commission, and he served as Cox's front man, honing his political skills and entertaining friends with lavish parties. Despite his association with the notorious Cox, Herrmann was considered honest and above reproach.

The American League was outdrawing the National League by the end of the 1902 season, and the NL was ready to make a deal. It had lost the war at the turnstiles. The National League owners met at the Victoria Hotel

Cincinnati Reds president Garry Herrmann presided over the peace talks to put an end to the baseball war. *Courtesy of the Library of Congress.*

in New York on December 9, 1902, and proposed that a committee meet with representatives of the AL with an offer to set up peace talks. Herrmann was chosen to lead the delegation because he had known Ban Johnson from Johnson's days as a reporter.

Both sides agreed to congregate on January 9, 1903, in Cincinnati's St. Nicholas Hotel at the southeast corner of Fourth and Race Streets. The St. Nicholas opened in 1864, and though it was only a four-story block building, under the management of Edward N. Roth, it had a reputation as one of the best hotels in the West. The National League committee consisted of Herrmann, St. Louis owner Frank de Haas Robison, Chicago's James A. Hart and Harry Pulliam, the just-elected president of the NL. On the AL side were Johnson, Comiskey, Boston's Charles Somers and Cleveland's John F. Kilfoyl. The hotel and bar were filled with baseball magnates and sportswriters from across the country, eager to glean any word about the proceedings. Herrmann stepped up and took the reins of the meeting.

The peace talks went on for fifteen hours over two days. Under Herrmann's guidance, disputes were quickly quelled. On the afternoon of January 10, the sides reached an accord, which was then typed up and signed. The terms regulated a schedule for both leagues and eliminated the player raids and attempts to undermine one another. The American League agreed to stay out of Pittsburgh, but the Baltimore team, which had barely survived the season, would relocate to New York, in direct competition with McGraw's Giants, as the Highlanders, though almost from the beginning fans called them the Yankees.

All parties involved in the Cincinnati pact credited Herrmann's leadership, integrity and fairness for coming to terms so quickly and agreeably. Comiskey, the former Reds manager now on the AL side, praised Herrmann: "That fellow talks right. He has a way of getting things in a jiffy, and he talks in a candid, straightforward way. If it is left to Mr. Herrmann, I think that there will never be another baseball war."[154] Herrmann had deftly employed his politicking skills and won over both sides as an impartial voice.

The owners ratified the agreement on January 19 in a special meeting in Cincinnati. The National Agreement established the National Commission, a three-man committee to oversee the leagues as a sort of ruling court, consisting of the two league presidents, Johnson and Pulliam, and a chairman; Herrmann was the obvious choice.

Surprisingly enough, the Cincinnati agreement did not address a championship series between the leagues, but as the 1903 season wound down and it was obvious that the Pittsburgh Pirates were running away

Enquirer cartoonist Winsor McCay commented on the baseball peace talks held in Cincinnati in this January 3, 1903 cartoon. *Courtesy of the* Cincinnati Enquirer/*Winsor McCay.*

Cincinnati's St. Nicholas Hotel hosted the baseball peace talks in January 1903. *From the Collection of the Public Library of Cincinnati and Hamilton County.*

with the NL title, and the same for the AL's Boston team (they wouldn't be called the Red Sox until 1908), Pirates owner Barney Dreyfuss suggested the league winners play a title series. The first World Series, called the World's Championship Games, was won by Boston, five games to three, over Pittsburgh.

Johnson and Herrmann both served on the National Commission until 1920, when it was replaced by a single baseball commissioner. Kenesaw Mountain Landis of Millville, Ohio, was selected in the wake of the Black Sox scandal, in which eight players on Comiskey's White Sox were accused of throwing the 1919 World Series to Herrmann's Reds team. Even the game Ban Johnson cleaned up was mired in the mud.

CAL CRIM, DETECTIVE

The *Cincinnati Times-Star* headline screamed "DETECTIVE SHOT BY A THIEF" in a colossal font usually reserved for war or World Series wins.[155]

On the morning of October 21, 1901, Detective Sergeant Cal Crim had been off duty and on his way to Central Police Station to meet up with a fellow detective so they could head off on a hunting trip in Aurora, Indiana, when Crim spotted John Foley, a notorious pickpocket and thief. Foley, aka "Foley the Goat," had been released from the Ohio Penitentiary the week before and was already wanted for a series of thefts when Crim caught up to him in front of a saloon on Sixth Street near Vine. Crim was of sturdy build, with an otherwise boyish face but for a deeply cleft chin and a moustache of the era, and had handled himself on a beat through some tough neighborhoods. He placed a hand on Foley's shoulder, and Foley, realizing he was nicked, pulled a pistol from his pocket and shot Crim twice in the right side. Crim staggered back and slid to the ground while Foley fled, only to run into two cops, who nabbed him after his pistol misfired.

Crim was taken to Cincinnati Hospital, but the prognosis was grim. The newspapers reported that it was a "mortal wound" and, using creative license, quoted the alleged dialogue as the dramatic scene unfolded. "I'm afraid he got me. I'm hit hard. There is no use talking. I am going to die," Crim reportedly told a colleague.[156] The bullets had entered his right side just below the nipple. One bullet went through his chest and out his shoulder. The other passed through his right lung and his liver and then was lodged

Cal Crim, pictured in the 1920s, spent twenty-seven years on the Cincinnati police force, rising to be chief of detectives. In 1917, he formed the Cal Crim Detective Bureau, the first private detective agency in Ohio. *Courtesy of the Cincinnati Enquirer archives.*

in his back, unable to be removed. His physician, Dr. Walter R. Griess, did what he could, but surgery was too risky; they had to let nature heal him. Crim was popular not only among fellow officers but also with the community and the press, so the public prayed and hung on every update in the newspapers as he clung to life.

Miraculously, he pulled through. He spent nearly a year convalescing, and the citizens of Cincinnati, so grateful that he survived, raised money and paid off his house at 3335 Menlo Avenue in Hyde Park. Crim returned to duty hardy as ever, under the watchful guidance of Dr. Griess, and went on to have an astoundingly long career as a sleuth.

One newspaper called Crim's life a Horatio Alger story. David Calvin Crim was born on December 12, 1864, in Oakland, Maryland. He ran away from home at age fifteen with only an eighth-grade education and hopped a train to see his sister in Cincinnati. Aboard the train, he had taken his shoes off his aching feet, and they fell between the cars. So he arrived in the Queen City in 1879 barefoot and broke. He obtained a job as a bellhop at the Galt House at Sixth and Main Streets for eight dollars a month plus room and board. He then sold newspapers, worked as a hotel clerk, and bought a barbershop. In 1886, he joined the Cincinnati Police Department, because police had shorter hours than firemen. After two years on a beat, he made detective.

His most sensational case was the murder of Pearl Bryan, a horrific crime that inspired books and songs about "poor Pearl." On February 1, 1896, Crim and his partner, Jack McDermott, were sent to investigate a woman's headless body that had been found on a farm near Fort Thomas, Kentucky. The head had been cut off, presumably to thwart identification,

so the detectives had to follow other clues. Found along with the body were a bloodstained union suit, a corset, a checkered kimono and a pair of size 3-B shoes marked with the number 22-11-62,458. Crim tracked the shoes to the manufacturer and then to the store Louis & Hays in Greencastle, Indiana. Store records showed two pairs had been sold. The buyer of one pair was located safe and sound. The other pair had been bought as part of a graduation outfit by Pearl Bryan, who lived on a farm on the outskirts of Greencastle. The family had thought she had been visiting relatives in Indianapolis, but they identified the clothing as belonging to the twenty-year-old.

The investigation revealed that Pearl had been dating Scott Jackson, a student at the Ohio College of Dental Surgery in Cincinnati at Court Street and Central Avenue, and had become pregnant. She wanted to get married, but Jackson arranged for another dental student, Alonzo M. Walling, to perform an abortion. When she refused, Jackson purchased cocaine, then legal, at a drugstore and administered the drug to Pearl. A coachman testified to transporting two men and a woman under the influence to the site where

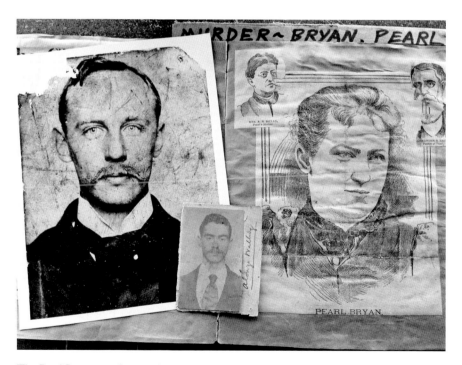

The Pearl Bryan murder was the most sensational case Cal Crim investigated. *Left to right:* Scott Jackson and Alonzo Walling, both convicted and executed, and Pearl Bryan and her parents. *Courtesy of the* Cincinnati Enquirer *archives.*

the body was found, but he had been spooked and ran off. Pearl was killed and decapitated, and then her body was dumped in the grass. The reservoirs were drained during the search for the head, but it was never found. Pearl Bryan's sister begged Jackson on her knees to return Pearl's missing head, but he claimed he knew nothing because he didn't kill her.

Recalling the case fifty years later, Crim shared his theory on the fate of the head. On the night of the murder, Jackson and Walling dropped off a heavy valise at a saloon at Ninth and Plum Streets. The next day, Jackson retrieved the bag and then brought it back empty. "It was only two squares to the dental college, where the furnace not only heated the building but also served as an incinerator for the rubbish of the place," Crim noted. Inside the bag, identified as Pearl's, police found bloodstains as well as leaves and soil from the farm where Pearl's body was found. "I don't think that the final disposition of her head is much of a mystery," Crim wrote.[157]

Jackson and Walling were convicted and sentenced to hang. Crim always felt that Walling was a simple young man who had fallen under the sinister influence of Jackson. He attended the execution in Newport, Kentucky, on March 20, 1897, in the hopes that Jackson would confess and spare the young man, but standing on the gallows, Jackson had nothing to say. "The trap was sprung," Crim wrote, "and I turned away as I have often wished I could turn away from many of the memories of the tragedy that, even after a lapse of half a century, I would most gladly forget."[158]

When Crim returned to duty in 1903 after recovering from the shooting, he was made assistant chief of detectives, then rose to chief of detectives in 1913. He retired that December after twenty-seven years on the police force and took a job as the house detective for the Gibson Hotel.

Crim partnered with Paul V. Ryan in 1917 to start the Cal Crim Detective Bureau in the Johnston Building at the southwest corner of Fifth and Walnut Streets. They moved across the street to the Traction Building in 1920. The private detective agency expanded to several cities, with over one hundred operatives who solved murders, kidnappings and thefts. The bureau provided security for several presidential inaugurations and even guarded a $100,000 rose on display at Music Hall. One of its top investigators, Ora E. Slater, solved the murder of crusading newspaper editor Don Mellett in Canton, Ohio. When a business put out a placard stating "Protected by Cal Crim Detective Bureau," people knew it was in good hands.

Crim was called in to investigate the infamous Black Sox scandal in 1919. When rumors swirled that gamblers had bribed Chicago White Sox players to throw the World Series, Ban Johnson of baseball's National Commission

Cal Crim spent nearly forty years as a private detective, in which he investigated the Black Sox scandal and provided security for six U.S. presidents. He worked until his death in 1953. *Courtesy of the* Cincinnati Enquirer *archives.*

hired Crim to find out the truth. Crim and Slater attended games in Chicago and Cincinnati, keeping their eyes on both the players and the stands, where they spotted several noted gamblers. Crim's report convinced Johnson that the fix was in, and Crim helped identify the gamblers involved. For his service, Crim was awarded a gold-plated lifetime pass good at any major-league ballpark.

Crim stepped down as president of the Cal Crim Detective Bureau in 1948, but he squelched talk that he was retiring. "Hell, no," he said. "I've got a lot of good years left. I'm only eighty-three."[159] He had slowed down in his ninth decade, no longer robust but still dapper and beloved by the community. He took back the reins of his agency two years later when his replacement died. Crim didn't really retire until his death of a heart ailment on December 19, 1953, at the age of eighty-nine. Including his time on the police force, Crim was a detective for sixty-seven years. He is buried in Vine Street Hill Cemetery in Clifton. His agency operated in the city as Cal Crim Incorporated until bought by Universal Protection Service in 2014, just shy of one hundred years of service.

DeHart Hubbard, the First Black Olympic Champion

DeHart Hubbard was never a superstar. He achieved some fame as one of the dominant track athletes of the 1920s, and in the 1924 Olympic Games in Paris, he entered the history books, becoming the first black athlete to win an individual gold medal. But Hubbard didn't have the larger-than-life personality of Babe Ruth or Jack Dempsey, who grabbed the headlines. On the track field, Jesse Owens would surpass him, but it was a trail Hubbard had blazed. The Cincinnati native is not even a household name in his hometown. His story is often retold as part of black history or sports legends, but the memory isn't retained. Every time Hubbard's record is brought up, it is as if for the first time. So, who was DeHart Hubbard? Perhaps the city's best all-around athlete if he had been allowed to play more sports, "the worthiest sort of champion, the type unwilling to rest on his renown."[160]

William DeHart Hubbard was born in Cincinnati on November 25, 1903, and grew up in Avondale, where the skinny speedster was known to run all around the neighborhood. He was named for A.J. DeHart, the first principal at Douglass School, a mostly black elementary school in Walnut Hills. Hubbard attended Douglass and then Walnut Hills High School, where he starred in several sports, not without some resistance. Hubbard's teammate George Mason recalled that at the start of the 1920 football season, a carload of men arrived at practice and declared that Hubbard, the team's only African American player, was ruled ineligible. The team unanimously agreed that if Hubbard were not allowed to play, none of them would play.[161]

University of Michigan alumnus Lon Barringer, in Charleston, West Virginia, read about Hubbard's prep achievements in the Cincinnati newspapers and worked to recruit him to his alma mater. In 1921, the *Cincinnati Enquirer* ran a scholarship contest to award $3,000 each to the ten high schoolers who sold the most newspaper subscriptions. Barringer reached out to Michigan alumni, including Branch Rickey, who in 1945 would sign Jackie Robinson to the Brooklyn Dodgers.[162] Hubbard turned to his African American neighbors, who rallied to send one of their own to college. Hubbard came in seventh place and offered his heartfelt thanks: "It is absolutely impossible for me to express my gratefulness, but I will endeavor by my future record to justify the confidence placed in me by those who sacrificed that I might win."[163] The *Enquirer* took a measure of pride in Hubbard, referring to him as "the Enquirer's scholar" as he rewrote the record books.

At the University of Michigan, the small, stocky Hubbard took six Amateur Athletic Union titles in the long jump and tied world records for the sixty-yard dash and one-hundred-yard dash. The coaches felt he should forego football and other sports to concentrate on track. He was one of the country's fastest runners, but his best event was the long jump: he did scissor kicks as he leaped, as though walking on air. The university had to extend the long-jump pit at Ferry Field beyond the usual twenty-five feet because Hubbard jumped farther than that distance ten times in his college career. He had two goals: to set the world long-jump record and to be the first of his race to be an Olympic champion.

Hubbard qualified for the 1924 Olympic Games in Paris, as did Ned Gourdin, an African American jumper from Harvard who had set the world record for long jump at 7.69 meters (25 feet, 2¾ inches). Onboard the ship ready to depart for Europe, Hubbard hastily scribbled a letter to his mother for her to tell his father: "I'm going to do my best to be the FIRST COLORED OLYMPIC CHAMPION." He wrote the words in all capitals, and underlined them.[164]

Though Hubbard would make history in the 1924 games, his accomplishment was overshadowed. The United States dominated, with forty-five gold medals—more than triple Finland's fourteen golds—and ninety-nine medals overall. Finnish long-distance runner Paavo Nurmi, "the Flying Finn," won five gold medals. U.S. swimmer Johnny Weissmuller, the future Tarzan of the movies, won three. British runners Harold Abrahams and Eric Liddell won the 100 meters and 400 meters, respectively, a story told in the 1981 Academy Award–winning film *Chariots of Fire*. A scene in the

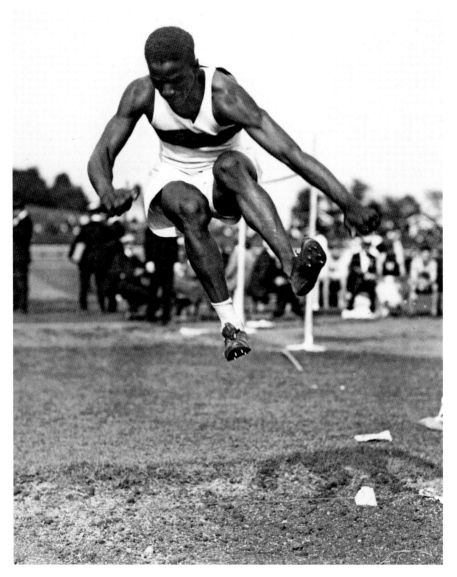

DeHart Hubbard set a record in the running broad jump at the National A.A.J. Junior Track and Field Championships in Newark, New Jersey, on September 9, 1922. *Courtesy of the* Cincinnati Enquirer *archives/Wide World Photos.*

film showing the Americans practicing has a single African American athlete running for the long-jump pit—a cameo appearance of DeHart Hubbard.

Hubbard's chance at history nearly ended on his first jump at trials. "On my first jump, I came down the runway pretty fast, committed a foul and

my heel came down in the gap at the back of the board," Hubbard told the *Cleveland Plain Dealer* in 1948. "Because I was wearing sprinter's shoes instead of the kind jumpers usually use, my heel was pretty badly bruised."[165] He qualified for finals, though the bad stone bruise on his right heel would hamper him. To make matters worse, the day before his jump, U.S. teammate Robert LeGendre set a new world record for the long jump at 7.76 meters (25 feet, 5½ inches) as part of the pentathlon event. "It upset me so much that I didn't sleep all night," Hubbard said.[166] LeGendre, though, was not entered in the long jump event. In Hubbard's final jump in the finals, he beat Gourdin with a jump of 7.44 meters (24 feet, 5¼ inches). It wasn't his best jump. U.S. coach Lawson Robertson said Hubbard was "off form" and had frequently beaten that mark.[167] But the jump was enough for the gold medal. Though Lawson called Hubbard "our best man,"[168] he was scratched from the hop, skip and jump event because of the stone bruise, and he wasn't entered in the running events, despite his great speed. "I always wondered how I would do against those boys from England," Hubbard said later.[169] Hubbard returned home to Cincinnati to a celebration as the first black Olympic champion, exactly what Hubbard set out to become.

Hubbard achieved his other goal, the world record in the long jump, at the last track meet of his college career. On June 13, 1925, at Chicago's Stagg Field, he set the record with 7.89 meters (25 feet, 10¾ inches), which stood for three years. At that same meet, he ran the one-hundred-yard dash in 9.8 seconds, 0.2 seconds slower than the world record.

At home in Cincinnati, Hubbard worked at the Cincinnati Recreation Commission and organized black basketball and baseball teams. In 1934, he started the Cincinnati Tigers, a professional segregated baseball team that used old Reds uniforms and played at Crosley Field. The Tigers were a charter member of the Negro American League in 1937 but disbanded after that season. In 1941, Hubbard left for Cleveland to work as racial relations adviser to the Federal Housing Authority and retired in 1969. He died on June 23, 1976, in Cleveland.

Perhaps it was because he spent his later years in Cleveland that Hubbard wasn't remembered in Cincinnati. His great-nephew J. Kenneth Blackwell, the former Cincinnati mayor and city councilman, tries to keep the torch of his memory alive, but the story needs to reach more people. The only monument to Hubbard is a bas-relief plaque in the seldom-used transportation tunnel under Second Street, where few see it. His track records eventually fell, as they all do, but Hubbard's place in history can never be eclipsed.

The Original Cincinnati Bengals

W hen the Cincinnati Bengals first took to the gridiron, the city was still recovering from the worst flood in the region's history and the great Paul Brown was coaching the Washington High School football team in Massillon, Ohio, to their third straight state championship title. The year was 1937. This wasn't the same as today's Bengals, who date back to the 1968 season. The original Cincinnati Bengals was a short-lived professional team that played from 1937 to 1941, though the whole enterprise wasn't far removed from the amateur game.

In the early days of professional football, upstart leagues competed for both the players and fans of the National Football League, which started in Canton, Ohio, in 1920. The sport had been played for years in high schools and colleges, but now money was involved. The fledgling leagues were so tenuous that attendance figures were regularly reported in newspaper headlines.

Cincinnati fielded a few pro football teams, but they couldn't win games or fans. The city's first pro team, the Cincinnati Celts (pronounced with a hard "c"), played from 1908 to 1923. It spent the 1921 season in the American Professional Football Association, the year before the league became the NFL. That season, the team scored a total of fourteen points, losing three shutouts for a 1-3 record. The Cincinnati Reds joined the NFL in 1933, though "competed" might be too strong a word. The Reds set records for the lowest points scored in an NFL season (thirty-eight points over ten games in 1933 and ten points in eight games in 1934). They were shut out in twelve

of the eighteen games they played before the team was suspended during the 1934 season for failure to pay league dues.

That year, the Model Shoe Co. approached Xavier University graduate Hal Pennington to coach an amateur football squad called the Cincinnati Model Shoes, or Models, who played at Northside Ball Park on Spring Grove Avenue near the cemetery. The Models had the best record in the Midwest League, but lost two championship games to the Louisville Tanks. Another Cincinnati team joined the league for the 1936 season. The Cincinnati Treslers, named for sponsor Tresler Oil, won only one game, even with Harry Rose, the father of Pete Rose, at halfback.

In 1937, Queen City Athletics Incorporated lured Pennington away from the Models to run their new pro franchise in the American Football League, one of several leagues that would use that name. Pennington assembled a team of quality college players, including Bob Wilke from Notre Dame and Hal McPhail from Xavier. But the biggest star was William Henry Harrison "Tippy" Dye, a three-sport standout who earned nine letters at Ohio State University. "Tippy" was short for Tippecanoe, the nickname of Dye's namesake, President Harrison. At five feet, seven inches and 140 pounds, the diminutive footballer was called a "mighty mite" and played left halfback. Earlier that year, Dye was part of the College All-Americans team led by football legend Sammy Baugh that beat the NFL's Green Bay Packers 6–0.

Football was a different game then. Players wore leather helmets with no facemasks and few pads. On most plays, teams ran the ball. The passing game was so limited, there were no wide receivers. The ball could be hiked to any of a platoon of runners in the backfield designated by their position from the line: quarter, half or full. Quarterback would evolve to be the passing position, but in the early days, the snap often went to the halfback, who usually ran with it, though he could also pass or kick. Field goals could be dropkicked or kicked from placement. And everyone played on both offense and defense.

Over the years, Pennington gave slight variations of how he came up with the name Bengals.[170] "I was in my mom's kitchen one day," he told the *Cincinnati Post* in 1967, "and on her stove there was a picture of this tiger with the name Bengal above it. I guess it was a trademark or something. Anyway, the tiger in the picture was so animated it inspired me. I figured Bengals would be a good name for the team."[171]

The Bengals started off with a victory. Postponed by a rainout, the team's debut was on Tuesday, October 5, 1937, against the Pittsburgh Americans. Some 7,500 attended the night game under the floodlights of Crosley Field,

which only two years earlier had lit up the first night baseball game. The Bengals started strong, blanking the Amerks, 21–0. Starting back Wilke ran for large gains and threw for a score, while fullback Don Geyer rushed for a touchdown and kicked two extra points. Ben Ciccone also returned an interception fifty-eight yards for a touchdown.[172] The rest of the season didn't live up to the promising start, though, as Cincinnati went 0-4-2 against the Rochester Tigers, New York Yankees and Los Angeles Bulldogs. They beat the Boston Shamrocks for a fourth-place finish. The Cincinnati eleven then crushed the Atlanta Crackers 36–7 in a nonleague game. But a charity game against the College All-Stars didn't go their way, as the pros lost 6–3 at snow-covered Nippert Stadium.

The league folded at the end of the season, but the Bengals continued as an independent

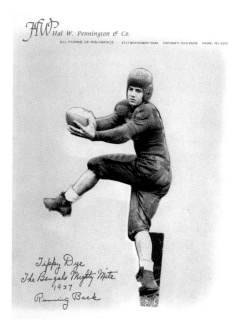

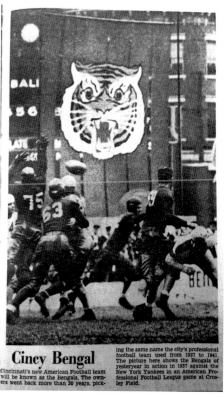

Top: Tippy Dye, the most popular player on the 1937 Bengals team, as shown on a media handout on stationery from team founder Hal Pennington. *Courtesy of the* Cincinnati Enquirer *archives.*

Bottom: Photos of the original Bengals on the field are rare. The Bengals, in dark jerseys, attempted to block the game-tying field goal by the New York Yankees at Crosley Field on October 17, 1937. *Courtesy of the* Cincinnati Enquirer.

team under Dana King after Pennington returned to the Models, which was then renamed the Blades. Dye had left before the end of the season, and John "Socko" Wiethe, another Xavier player, joined as a tackle. The team then played its home games at Xavier University Stadium. Under King, the Bengals won six straight to start the 1938 season, and even fared well against a couple of NFL teams, defeating the Chicago Bears 17–13 and battling the Chicago Cardinals to a 14–14 tie. The Bengals finished 7-2-1. The 1939 season in the American Professional Football League had similar results, with a 6-3 record. But the next season, the Bengals defected to yet another AFL, where they won only twice in two years. The Bengals' final game was a 13–7 loss to the New York Americans at Yankee Stadium on November 30, 1941. The following Sunday, the Japanese launched a surprise attack on Pearl Harbor. By the next season, many players were fighting a war, and the league closed.

Several Bengals found success elsewhere. Pennington became a legendary coach of amateur baseball in Cincinnati, notching 1,500 wins and a record four National Amateur Baseball Federal World Series titles. Tippy Dye worked as an assistant under Paul Brown at Ohio State, coached the University of Washington basketball team to the Final Four and helped build the successful University of Nebraska football program. "Socko" Wiethe was an All-Pro for the Detroit Lions and a football and basketball coach at the University of Cincinnati before becoming chairman of the Hamilton County Democratic Party.

Wiethe popped up in Bengals lore again in 1967, when he led a group competing for the new football franchise in Cincinnati. The year before, the city had been primed to win an expansion NFL team with hope of a new stadium and hall-of-fame coach Paul Brown at the helm. Brown had led his namesake Cleveland Browns to the pinnacle of football success until Browns owner Art Modell fired him as coach in 1963. Stung by the betrayal, Brown hoped to start over in Cincinnati with a new NFL team, but politics helped swing the expansion team to New Orleans, and the Queen City was instead offered an AFL team with the promise that it would join the NFL when the two leagues merged in 1970. When Brown dragged his feet, Wiethe's group put in a bid for the franchise and drew up a team called the Cincinnati Romans, donning white helmets crowned with laurel wreaths. But Brown was awarded the AFL expansion team, which debuted in 1968 and played at UC's Nippert Stadium until Riverfront Stadium was completed in 1970. A contest was held to pick a name for the team, with Buckeyes the most popular choice. But that was the nickname of Ohio State. Brown instead

Original Bengals founder Hal Pennington *(right)* shares a scrapbook of the 1937 team with the new Bengals founder, Paul Brown, in 1967. *Courtesy of the* Cincinnati Enquirer/ *Fred Straub.*

chose Bengals, to give the team a link with past professional football in Cincinnati. "If we can pick up a thread of tradition we think it's good," Brown said at the time. "We feel at home with the name Bengals."[173]

Toy Stories

Not all toys are made by Santa's elves. Some of the favorites found under the Christmas tree were created, designed and manufactured in Cincinnati, including the Easy-Bake Oven, Play-Doh, *Star Wars* action figures, and playing cards, all of which have been inducted in the National Toy Hall of Fame.

U.S. Playing Card Company

Bicycle playing cards are the most popular in the world, used by gamblers, magicians and regular folks playing bridge, poker and solitaire. Everyone knows the cards with the bicycle motif on the back, but the brands are more recognizable than the company. Bicycle and a dozen other playing card brands, including Bee and Hoyle, are made by the United States Playing Card Company, which has been headquartered in the Cincinnati area for nearly 150 years.

The company's history began in January 1867, when printers A.O. Russell and Robert J. Morgan partnered with James M. Armstrong and John F. Robinson to form a printing company known as Russell, Morgan & Co. They leased the Enquirer Job Office, the newspaper's facility for printing posters and books, at 80 College Street, a north–south street west of Vine, between Sixth and Seventh Streets. They moved to Race Street in 1872.

Initially, the company printed placards, labels and circus posters. Robinson, one of the partners, was also the owner and manager of the John Robinson Circus, the famous touring circus his father founded in 1842. He wintered, along with his animals, in Terrace Park.

Russell suggested that the company start printing playing cards, and their first deck came off the press on June 28, 1881. They started using the name United States Printing Company, and spun off the card business as the United States Playing Card Company.

The Bicycle brand was introduced in 1885. The company bought out several competitors, becoming one of the major playing-card manufacturers. In 1900, U.S. Playing Card relocated from its downtown plant near Eggleston Avenue and Fifth Street to a thirty-acre site at 4950 Beech Street in Norwood. The signature Neo-Romanesque bell tower was added to the factory in 1926. At the site in 1923, U.S. Playing Card started AM radio station WSAI to broadcast lessons on playing bridge. The signal was so strong that it was heard as far away as New Zealand. WSAI was sold to Crosley Broadcasting Corporation in 1926. A few years later, the U.S. Playing Card Company was included in the mosaic murals at Union Terminal honoring Cincinnati's industries.

During World War II, the U.S. Playing Card Company produced cards for POWs. The cards had escape maps that could be revealed when the cards were dipped in water. *Courtesy of the Cincinnati Enquirer/ Jim Callaway.*

The card company played a secret role in two wars overseas. During World War II, the company worked with the U.S. government to make special packs to be dropped for American prisoners of war in German territory. When moistened, the cards could be peeled to reveal maps showing escape routes. The company also printed cards that depicted various tanks and aircraft to help soldiers identify enemy equipment. During the Vietnam War, the company answered a request to assemble packs consisting of only the ace of spades, which the superstitious Viet Cong interpreted as a sign of death. The cards were airdropped into the fields to spook the enemy.

U.S. Playing Card became a subsidiary of Jarden Corporation in 2004, and in 2008, it relocated across the river to Erlanger, Kentucky.

Magic 8 Ball

Was the Magic 8 Ball fortunetelling toy inspired by famous Cincinnati medium Laura Pruden? Signs point to yes.

The idea for the ubiquitous oracle came from Pruden's son, Albert C. Carter. The Price Hill spiritualist was known worldwide for her slate-writing séances, in which the dead would write messages in chalk. Sherlock Holmes creator Sir Arthur Conan Doyle, an avowed believer in spiritualism, was convinced of her authenticity by a séance with his late mother and called Pruden "one of the great mediums of the world."[174] Shortly after his mother's death in 1939, Carter created a toy fortuneteller based on the same idea of a spirit answering questions. He put together a tube filled with a dark liquid and a pair of floating dice with responses printed on the sides that reveal one's fortune.

Carter took his toy to local store manager Max Levinson, who brought in his brother-in-law, Abe Bookman (née Buchmann), a graduate of the Ohio Mechanic's Institute, to help develop the concept. Together they formed Alabe Crafts (combining their names, Al and Abe) at 348 West Fifth Street at Central Avenue. The first incarnation of the toy was the Syco-Seer, dubbed the "miracle home fortune-teller," which was still in the original tube design. Carter applied for a patent in 1944 for a "liquid filled dice agitator" and then added Bookman and Levinson as partners. Carter died in 1948, a few months before the patent was granted.

Bookman continued to modify and improve the toy design, and the tube was encased in a ball shape. Then, in 1950, Chicago-based Brunswick Billiards commissioned Alabe to make a version resembling a black-and-white 8-ball, and that somehow captured people's attention. The basic concept is the same. You hold the Magic 8 Ball with the screen facing down and ask a yes-or-no question. Then turn the ball over. Inside, a twenty-sided polygon bubbles to the surface and displays the answer. Dr. Lucien Cohen, a psychology professor at the University of Cincinnati, was consulted on the responses: ten positive, five negative and five neutral.

Alabe Crafts was sold to Ideal Toys in 1971 and journeyed through company acquisitions by Tyco Toys in 1987 and Mattel in 1997. Mattel reports about one million Magic 8 Balls sold each year. Bookman died in 1993 and is buried in Rest Haven Memorial Park in Evendale, Ohio. Carter and his mother are both buried in Spring Grove Cemetery.

KENNER

For fifty-three years, Kenner Products churned out popular toys that spurred children's imaginations and helped to define their childhood. Just about everyone played with Kenner toys. During the 1970s and '80s, Kenner grew to be one of the top toymakers. Although parent company Hasbro shut down Kenner in 2000, its classic toys remain popular with collectors and nostalgic adults.

The Steiner brothers, Albert, Philip and Joseph, founded Kenner Products in 1947. The name came from Kenner Street near Union Terminal, where they had previously owned the Cincinnati Soap Co., which they sold to Procter & Gamble in 1938. Flooded out of the Kenner Street factory in 1945, the Steiners moved to 912 Sycamore Street, where the toy company was born. Their first toy was the Bubbl-Matic Gun, inspired by watching a boy make bubbles by waving his hand dipped in soapy water.

The company was a pioneer in television advertising by sponsoring the *Captain Kangaroo* children's show in 1958. Kenner's Gooney Bird squawked the slogan, "It's Kenner! It's fun!" on TV ads, including one with a Muppet version of the mascot performed by Jim Henson.

Kenner produced several popular toys, from Spirograph to Close 'n Play Phonographs and Baby's Alive, but its biggest hit was the Easy-Bake Oven, introduced in 1963. Inspired by New York City pretzel vendors, Ronald Howes and James O. Kuhn invented a toy oven that used a common 100-watt light bulb to bake goodies. The design changed with the times, and the product now resembles a microwave. With the demise of the incandescent light bulb, toy engineers switched to a heating element in 2006. More than 23 million of the ovens have been sold in fifty years.

In 1967, the Steiners sold Kenner to cereal giant General Mills, which added Parker Brothers and Play-Doh's Rainbow Crafts to its toy division. Kenner expanded with a manufacturing plant in Oakley and a distribution center in Norwood and in 1976 moved its headquarters to the Kroger Building at 1014 Vine Street. The original Kenner building on Sycamore, with the abstract mural of a boy playing marbles by artist David Day, was torn down for the Hamilton County Justice Center.

When filmmaker George Lucas made *Star Wars* in 1977, science fiction had mostly a cult following, and no one expected the film to do well. So, when Lucas approached toy companies from Mattel to Mego to license *Star Wars* toys, they all turned him down. At Kenner, designer Jim Swearingen read the script and convinced his bosses they had to make the toys. At that

The assembly line at Kenner Products in Oakley boxes up the popular *Star Wars* toys that made Kenner one of the top toy companies in the 1970s and '80s. *Courtesy of the* Cincinnati Enquirer/*Mark Treitel.*

time, toys from television properties, such as Kenner's *Six Million Dollar Man* doll, worked because of the lengthy exposure of TV, but movies weren't in theaters long enough. The designers knew they wanted to make toys of the spaceships, but the usual eight- or twelve-inch dolls would make that impossible, so they instead created three and three-quarter-inch plastic action figures that would become the new industry standard.

But the figures would take a year to develop and wouldn't be ready for Christmas 1977, so the company tried a bit of innovative marketing. Kenner whipped up a cardboard stand and an "Early Bird Certificate Package" that promised delivery of the first four figures (Luke Skywalker, Princess Leia, Chewbacca and R2-D2) when they were available the following year. The company essentially sold parents an empty box, an IOU to put under the tree on Christmas morning. It was crazy, but it worked. Nearly 300,000 certificates were sold, and a few months later, any disappointments were forgotten. The Kenner action figures, vehicles and play sets were a key part of the *Star Wars* phenomenon, raking in a reported $200 million in sales. The success helped Kenner land other licenses, including Care Bears, Strawberry Shortcake, *Ghostbusters* and Batman.

Tonka Corp. acquired Kenner Parker Toys in 1987 but, saddled by debt, sold it all to Hasbro in 1991. That brought about several changes. Hasbro closed the Oakley plant and moved Kenner's headquarters to 615 Elsinore Place near Eden Park. Hasbro closed the last of Kenner's operations in Cincinnati in 2000. The Rhode Island–based company still offers many former Kenner products under the Hasbro name, but they are no longer made in Cincinnati.

For collectors, Cincinnati is a treasure-trove of old Kenner toys. In an episode of the Travel Channel's show *Toy Hunter*, a prototype of an unproduced Boba Fett action figure with a rocket-firing jetpack owned by Geoff Hoffman of Queen City Comics sold for $17,000. Even for those who didn't hang on to their old toys, fond memories of playing with Kenner toys are priceless.

PLAY-DOH

Play-Doh, the classic children's modeling compound, wasn't originally a toy. The clay-like dough started out as a wall cleaner used to rub coal soot off of nonwashable wallpaper. In 1927, brothers Cleo and Noah McVicker took over Kutol Products (pronounced "cut-all"), a struggling soap company in Cincinnati, and a deal with the local Kroger grocery store chain helped make Kutol Wall Cleaner the top seller for twenty years.

After Cleo died in a plane crash in 1949, his son Joe McVicker and son-in-law Bill Rhodenbaugh tried to save the company, but the market disappeared along with wood-burning stoves. Kay Zufall, Joe's sister-in-law in New Jersey, read in a magazine about children making Christmas ornaments out of wallpaper cleaner and tried it out at her community nursery school. She then shared her idea for Kutol turning its product into a toy.

Joe had his Uncle Noah work up a batch that was nontoxic with an almond scent. Coloring was added to the off-white goop—originally red, blue and yellow—so kids could mix any color of the rainbow. Joe named it Rainbow Modeling Compound, but Kay and her husband, Bob, suggested the name Play-Doh. In 1955, Play-Doh debuted in the Cincinnati elementary schools.[175] Soon it was everywhere.

Rainbow Crafts spun out of Kutol, which is still a soap maker in the city, and set up a plant on Highland Avenue in Norwood. Several people contributed to the development of Play-Doh, including Rhodenbaugh, the

Joe McVicker, president of Rainbow Crafts and one of the inventors of Play-Doh, sits atop boxes of the popular modeling compound in 1959. *Courtesy of the* Cincinnati Enquirer *archives.*

Zufalls and Dr. Tien Liu, a chemist who made several modifications to the formula. But the patent for Play-Doh was granted to only Joe and Noah McVicker in 1960.

A born salesman, Joe convinced Captain Kangaroo and Miss Frances to plug Play-Doh on their children's TV shows, and the exposure made Play-

Doh a national hit. John Ruthven, the respected wildlife artist, began his career designing the early Play-Doh packages and created the little boy mascot known as Play-Doh Pete. In 1960, two engineers from General Electric invented the Play-Doh Fun Factory, which pressed the colored blobs into various shapes, adding a whole new dimension to the toy. Joe sold Rainbow Crafts to General Mills for $3 million in 1965, and Play-Doh was put under the Kenner brand.

Play-Doh is not supposed to be edible, but to anyone who grew up with the stuff, its taste is as familiar as its smell. A sniff of that salty-sweet scent instantly takes us back to kindergarten. More than three billion cans of Play-Doh have been sold around the world in sixty years. Until 1991, when Hasbro purchased Kenner and moved Play-Doh to its Playskool division, every can was made in Cincinnati.

UNO

The favorite family card game Uno was created by Merle Robbins and his family in Reading, Ohio, a Cincinnati suburb. The family loved playing cards and developed their own game derived from Crazy Eights about 1969. They scribbled their own designations on the faces of regular cards and made up the rules as they went along, and Merle's wife, Marie, wrote them down.

The creators of Uno *(left to right)*, Merle Robbins, his son Ray Robbins, Ray's wife, Kathy, and Merle's wife, Marie, play the card game that became a sensation. *Courtesy of the* Cincinnati Enquirer/*Mark Treitel.*

Merle was the owner of a local barbershop in 1971 when he—along with his wife and their son and daughter-in-law, Ray and Kathy Robbins, both Reading schoolteachers—decided to print up some decks of the game they called Uno. Cincinnati graphic artist Bob Grove, who made the new logo for the Cincinnati Royals basketball team, designed the cards. The couples paid $8,000 up front to print 5,000 games and then sold them by word of mouth to friends, in Merle's barbershop and out of their camper down in Florida for three dollars a deck.

The game caught on enough that in 1972, the Robbins family sold Uno to Robert Tezak, a former funeral director from Joliet, Illinois, for $50,000 and 10¢ a game in royalties.[176] Tezak formed International Games Incorporated, and Uno became a sensation in the 1980s. Mattel acquired the company in 1992, and Uno has been a top seller in a wide variety of formats, proving that the classic game is still número uno.

AFTERWORD

Since I started working on this book, Cincinnati's ArtWorks has announced mural paintings, to be revealed in 2016, of three subjects that were covered in these pages. Annie Oakley, Winsor McCay's Little Nemo and toys made in Cincinnati will be painted on three-thousand-square-foot brick canvases, joining more than one hundred ArtWorks murals celebrating art and Cincinnati history throughout the community. So, word is getting out. Now go forth and tell all about the people and things we met. As we learn these stories, as we share them and remember them, history will no longer be hidden.

NOTES

Chapter 1

1. Drake, *Picture of Cincinnati*, 202.
2. Fletcher, et al., "Serpent Mound: A Fort Ancient Icon?"
3. Herrmann, et al., "New Multistage Construction Chronology."
4. MacLean, "Great Serpent Mound," 44–47.
5. Holmes, "Sketch of the Great Serpent Mound," 624–28.
6. Romain, *Mysteries of the Hopewell*, 253.
7. Putnam, "Serpent Mound of Ohio," 871.

Chapter 2

8. The Second Charter of Virginia, May 23, 1609, in Thorpe, *Federal and State Constitutions*, 3,795.
9. Brown, *Frontiersman*, 92.
10. Clark, *Conquest of the Illinois*, 13.
11. Draper, *Life of Daniel Boone*, 441.
12. Lytle, "Personal Narrative of William Lytle," 4–5.
13. Quoted in Howe, *Historical Collections of Ohio*, 389.
14. Ibid.
15. Beckner, "Reverend John D. Shane's Interview," 98.
16. Bakeless, *Background to Glory*, 299.
17. Kenton, *Simon Kenton*, 161, 318–19.

Chapter 3

18. Prothero, *Purified by Fire*, 47–48.
19. *Boston News-Letter & City Record*, February 18, 1826. References discussed in Carp, *Defiance of the Patriots*.
20. "Revolutionary Reminiscence…"; see Flint, *Western Monthly Review*, vol. 1, 145.
21. Possibly a reference to Samuel Gray, a victim of the Boston Massacre in 1770.
22. Flint, *Western Monthly Review*, vol. 1, 145–49.
23. *Boston Gazette*, September 6, 1827.
24. Thatcher, *Traits of the Tea Party*, 261–62.
25. "Lafayette's Landing at Cincinnati"; see Flint, *Western Monthly Review*, vol. 3, 445.
26. *Daily Cincinnati Gazette*, January 23, 1829.
27. E-mail exchange with author, April 2014.

Chapter 4

28. Venable, *Beginnings of Literary Culture*, 304.
29. Juettner, *Daniel Drake*, 3.
30. Osler, *Aequanimitas*, 325.
31. Billings, "Higher Medical Education," 174–89.
32. Juettner, "John L. Richmond"; see Kreidler and Castle, *Lancet-Clinic*, 95.
33. Richmond, "History of a Successful"; see Drake, *Western Journal*, 487.
34. *Lancet-Clinic*, "Correspondence," February 17, 1912; see Kreidler and Castle, *Lancet-Clinic*, 195–96.
35. Knight, "Life and Times of Jesse Bennett."
36. Centers for Disease Control, www.cdc.gov/nchs/fastats/delivery.htm.

Chapter 5

37. Tom Trollope quoted in Trollope, *Domestic Manners*, xxxi.
38. Wright, "Henry Bellows," 63.
39. Descriptions of "Infernal Regions" from Frances Trollope (Trollope, *Domestic Manners*, 62–64), Hiram Powers (Wright, "Henry Bellows," 63), Linus S. Everett (quoted in Trollope, *Domestic Manners*, 63–64) and Donald Smalley (Trollope, *Domestic Manners*, xxx–xxxiv).

40. Wright, "Henry Bellows," 63.
41. Ibid.
42. Trollope, *Domestic Manners*, 62–63.
43. Baluk, "Proprietary Museums," 226.
44. Hingston, *Genial Showman*, 39.
45. Cincinnati Museum Center, www.cincymuseum.org/research/vertebrate.

Chapter 6

46. Interview with author, October 2014.
47. The exact relation is unclear, though several Archibalds and Mary Janes are in both Mary Jane Irwin's line and Jane Irwin Harrison's line, both deriving from Mercerburg, Pennsylvania, suggesting cousins of some degree.
48. Irwin, "Compositions of Miss Mary Jane Irwin."
49. Interview with author, October 2014.
50. Irwin, "Compositions of Miss Mary Jane Irwin."

Chapter 7

51. Niven, *Salmon P. Chase*, 96.
52. Hart, *Salmon P. Chase*, 435.
53. Schurz, *Reminiscences of Carl Schurz*, 172.
54. Chittenden, *Recollections of President Lincoln*, 379–80.

Chapter 8

55. Proclamation by Major General Lew Wallace, appearing in the *Cincinnati Enquirer* (hereafter cited as *Enquirer*), September 2, 1862.
56. Ibid.
57. Proclamation by Mayor George Hatch, appearing in the *Enquirer*, September 2, 1862.
58. *Cincinnati Gazette*, September 2, 1862.
59. Clark, *Black Brigade*, 3.
60. Ibid., 5. Which of the profane words was censored was reversed in 1864.
61. *Cincinnati Gazette*, "Colored Brigade," September 4, 1862.

62. Muster rolls list 706 members of the Black Brigade, but the names of a few hundred more were never recorded.
63. Stern, "Siege of Cincinnati," 175.
64. Neff, "Siege of Cincinnati," 272.
65. Proclamation by Major General Lew Wallace, September 12, 1862; see Goss, *Cincinnati: The Queen City*, 338.
66. Clark, *Black Brigade*, 10.

Chapter 9

67. Styple, *McClellan's Other Story*, 296.
68. E-mail exchange with author, October 2013.
69. Unpublished manuscript, William Dickson Papers; see Styple, *McClellan's Other Story*, 21.
70. McClellan letter to his wife, October 11, 1861; see McClellan, *Civil War Papers*, 106.
71. Styple, *McClellan's Other Story*, 76–77.
72. William Dickson Papers; see Styple, *McClellan's Other Story*, 14.
73. Biddle, "Recollections of McClellan," 469.
74. Styple, *McClellan's Other Story*, 124.
75. Ibid., 159–66.
76. Biddle, "Recollections of McClellan," 469.
77. McClellan, *Civil War Papers*, 589.
78. Piatt, *Memories of the Men*, 290–94.
79. Ibid., 294.
80. Ibid., 295.

Chapter 10

81. *Cincinnati Commercial*, February 4, 1863.
82. Potter, Sultana *Tragedy*, 196; Salecker, *Disaster on the Mississippi*, 206. The most complete lists available of passengers and crew of the *Sultana* are found in Potter, Sultana *Tragedy*, 195–260, and Salecker, *Disaster on the Mississippi*, 223–90.
83. Berry, *Loss of the* Sultana, 7.

Chapter 11

84. *Enquirer*, "Guerrillas Near North Bend—The Ohio and Mississippi Train Attacked—Passengers and Adams Express Safe Robbed," May 8, 1865; *Cincinnati Commercial*, "The Guerrilla Operations," May 8, 1865.

85. Ibid.

86. *Enquirer*, "More About the Guerrilla Attack Upon the Cars of North Bend—Some of the Incidents Thereto Appertaining Not Before Related," May 9, 1865.

87. Ibid.

88. *Enquirer*, "Covington News," May 9, 1865.

89. *Cincinnati Daily Times*, "The Late Robbery of the Ohio and Mississippi Railroad Train," May 8, 1865.

90. *Enquirer*, "The Capture of a Train on the Ohio and Mississippi Railroad—Arrest of Several of the Alleged Robbers, &c," May 13, 1865.

91. Ibid.

92. "Circular No. 3," April 29, 1865, Major General John M. Palmer, in Palmer, *Personal Recollections*, 259.

93. *Cincinnati Daily Times*, May 8, 1865.

Chapter 12

94. Cockerill, "Lafcadio Hearn," 476.

95. *Enquirer*, "London Sights: An Evening in Whitechapel," November 4, 1872.

96. *Enquirer*, "Giglampz," October 4, 1874.

97. *Enquirer*, "Violent Cremation," November 9, 1874.

98. *Ye Giglampz* 1 (June 21, 1874).

99. *Cincinnati Commercial*, "Steeple Climbers," May 26, 1876.

100. Hearn, *Inventing New Orleans*, xi.

Chapter 13

101. Kasper, *Annie Oakley*, 22.

102. Oakley, "Story of My Life," printed in *Pittsburgh Press*, November 24, 1926.

103. Ibid.

104. Kasper, *Annie Oakley*, 16.
105. *Pittsburgh Dispatch*, February 4, 1903; *Charlotte Observer*, July 6, 1924; *Dayton Sunday Journal*, December 14, 1924.
106. *Charlotte Observer*, July 6, 1924.
107. Kasper, *Annie Oakley*, 20.
108. Advertisement in *Enquirer*, May 26, 1880, 5.
109. *Enquirer*, January 20, 1881.
110. *Enquirer*, April 3, 1881.
111. *Williams' Cincinnati Directory*, 1880, 985.
112. *Enquirer*, "Our Hotels," May 7, 1878.
113. *Williams' Cincinnati Directory*, 1881, 430. The listing for Nicholas Gorden cites his occupation at a "shooting gallery" at 437 Vine.
114. Kasper, *Annie Oakley*, 33.
115. Oakley, "Story of My Life."
116. *Enquirer*, January 2, 1891.
117. *Enquirer*, "Annie Oakley Alive," January 12, 1891.

Chapter 14

118. Flannery, *John Uri Lloyd*, 60.
119. Ibid., 61. Renowned pharmacist James H. Beal gave the title to Lloyd in an address to the National Eclectic Medical Association in 1920.
120. Goss, *Cincinnati: The Queen City*, 740.
121. Flannery, *John Uri Lloyd*, 123–24.

Chapter 15

122. Wright, *Representative Citizens of Ohio*, 456.
123. Dow, "Once There Was One Little Store," 16.
124. Dow, "Women as Pharmacists," 179.
125. Ibid., 180.
126. Dow, "Once There Was One Little Store," 19–20.
127. Wright, *Representative Citizens of Ohio*, 458.
128. "Cora M. Dow," 483.
129. *Enquirer*, "Melody and Oratory Unite to Pay Honor to Memory of Martha Cora Dow," January 6, 1916.

130. Ibid.
131. Ibid.

Chapter 16

132. Schorger, *Passenger Pigeon,* 205; Greenberg, *Feathered River,* 1.
133. Aububon, "Account of the Wild Pigeon."
134. King, *Sportsman and Naturalist,* 121–22.
135. Schorger, *Passenger Pigeon,* 201–02.
136. Mershon, *Passenger Pigeon,* 54.
137. Schorger, *Passenger Pigeon,* 27.
138. *Enquirer,* "Last Passenger Pigeon Carried Off By the Death of 'Martha' at the Zoo," September 2, 1914.
139. Kraft, "Martha."
140. *Cincinnati Times-Star,* "Far-Famed Last Parrakeet [*sic*] of Its Kind Is Mourned at Zoo," February 22, 1918.

Chapter 17

141. Barrier, *Hollywood Cartoons,* 10.
142. Canemaker, *Winsor McCay,* 11.
143 McCay, *Best of Little Nemo,* 89.
144. Briggs, *How to Draw Cartoons,* 118.
145. Canemaker, *Winsor McCay,* 44.
146. Ibid., 257.
147. *Disneyland,* "Story of the Animated Drawing."
148. Canemaker, *Winsor McCay,* 255.
149. Holtz, "News of Yore 1908."
150. Blackbeard, "Yellow Kid," 70.

Chapter 18

151. Murdock, *Ban Johnson,* 10. Ban Johnson's date of birth is in dispute, but the family Bible lists January 6, 1864.
152. Ibid., 39.
153. Allen, *American League Story,* 1.

154. *Cincinnati Commercial Tribune*, "Peace Talk Picked Up in the Lobby," January 10, 1903.

Chapter 19

155. *Cincinnati Times-Star*, "Detective Shot By a Thief," October 21, 1901.
156. *Enquirer*, "Thief's Murderous Weapon Lays Low Detective Sergeant Cal Crim," October 22, 1901.
157. *Enquirer*, "Detective Reviews His Role in Pearl Bryan Murder Case," February 3, 1946.
158. Ibid.
159. *Cincinnati Post*, "'Fie!' on Retirement, Says Cal Crim, 83," July 14, 1948.

Chapter 20

160. Baskin and Wheeler, *Schoolboy Legends*, 57.
161. Ibid., 56.
162. Behee, *Hail to the Victors!*, 13.
163. *Enquirer*, "Marie Scanlon Leads Long List of Candidates For Scholarships Awarded by the Enquirer," August 28, 1921.
164. Scans of the letter available online from the Cincinnati Museum Center, library.cincymuseum.org/aag/documents/hubbardletter.html.
165. Interview in *Cleveland Plain Dealer*, 1948, quoted in Gildea, "Hubbard's Long Jump."
166. Ibid.
167. Robertson, "Hubbard Off Form."
168. Robertson, "Negro Athlete Is Out."
169. Interview in *Cleveland Plain Dealer*, 1948, quoted in Ganey, "'I was fast.'"

Chapter 21

170. Pennington wrote, "We needed a nickname. The press suggested we sponsor a name-the-team contest. While I was sitting at home in the kitchen watching television, this big tiger appeared on the screen and underneath was the word Bengal. Then I said: 'There's a ferocious tiger called a Bengal and that's just perfect for a nickname for our team.'" But

it was unlikely he was watching television in 1937. Hal Pennington, as told to Jack Murray in Murray, "Early Days of Pro Football."

171. Lawson, "Brown's New Club."

172. Bohne, "Bengals Down Amercks."

173. Heim, "Bengals to Roar."

Chapter 22

174. Doyle, *Our Second American Adventure*, 44.

175. Walsh, *Playmakers*, 116–17.

176. Vonderhaar, "Becoming Numero Uno."

Bibliography

Abrams, Roger I. *The First World Series and the Baseball Fanatics of 1903*. Boston: Northeastern University Press, 2003.

Allen, Lee. *The American League Story*. Rev. ed. New York: Hill & Wang, 1965.

Aububon, John James. "Account of the Wild Pigeon of America." *London Magazine*, June 1827.

———. *The Birds of America*. New York: V.G. Audubon, 1856.

Bakeless, John. *Background to Glory: The Life of George Rogers Clark*. Lincoln: University of Nebraska Press, 1957; reprint, 1992.

Baluk, Ulana Lydia. "Proprietary Museums in Antebellum Cincinnati: 'Something to please you and something to learn.'" Doctoral thesis, University of Toronto, 2000.

Barrier, Michael. *Hollywood Cartoons: American Animation in Its Golden Age*. New York: Oxford University Press, 1999.

Baskin, John, and Lonnie Wheeler. *Schoolboy Legends: A Hundred Years of Cincinnati's Most Storied High School Football Players*. Wilmington, OH: Orange Frazer Press, 2009.

Beckman, Wendy Hart. *Founders and Famous Families: Cincinnati*. Covington, KY: Clerisy Press, 2014.

Beckner, Lucien, ed. "Reverend John D. Shane's Interview with Pioneer William Clinkenbeard." *Filson Club History Quarterly* 2 (April 1928).

Behee, John. *Hail to the Victors!* Ann Arbor: University of Michigan, 1974.

Berry, Chester D. *Loss of the* Sultana *and Reminiscences of Survivors*. Lansing, MI: Darius D. Thorp, 1892.

Biddle, William F. "Recollections of McClellan." *United Service* 11 (May 1894).

Billings, John Shaw. "Higher Medical Education." *American Journal of Medical Sciences* 151 (July 1878).

Bisland, Elizabeth. *The Life and Letters of Lafcadio Hearn.* Boston: Houghton Mifflin Co., 1906.

Blackbeard, Bill. "The Yellow Kid, the Yellow Decade." *R.F. Outcault's The Yellow Kid: A Centennial Celebration of the Kid Who Started the Comics.* Northampton, MA: Kitchen Sink Press, 1995.

Blue, Frederick J. *Salmon P. Chase: A Life in Politics.* Kent, OH: Kent State University Press, 1987.

Bohne, Bob. "Bengals Down Amercks, 21–0 Before 7,500; Wilke and Dye Are Chief Cogs in Victory." *Enquirer,* October 6, 1937.

Briggs, Clare. *How to Draw Cartoons.* New York: Harper & Brothers, 1926.

Brown, Meredith Mason. *Frontiersman: Daniel Boone and the Making of America.* Baton Rouge: Louisiana State University Press, 2008.

Bryant, William O. *Cahaba Prison and the* Sultana *Disaster.* Tuscaloosa: University of Alabama Press, 1990.

Canemaker, John. *Winsor McCay: His Life and Art.* 2nd ed. New York: Harry N. Abrams, 2005.

Carp, Benjamin L. *Defiance of the Patriots: The Boston Tea Party & the Making of America.* New Haven, CT: Yale University Press, 2010.

Chittenden, L.E. *Recollections of President Lincoln and His Administration.* New York: Harper & Brothers, 1891.

Clark, George Rogers. *The Conquest of the Illinois.* Edited by Milo Milton Quaife. Chicago: Lakeside Press, 1920.

Clark, Peter H. *The Black Brigade of Cincinnati: Being a Report of Its Labors and a Muster-Roll of Its Members; Together with Various Orders, Speeches, etc. Relating to It.* Cincinnati, OH: Joseph B. Boyd, 1864; reprint: New York: Arno Press and the New York Times, 1969.

Cockerill, John A. "Lafcadio Hearn: The Author of Kokoro." *Current Literature* 19, no. 321 (June 1890). Reprinted from *New York Herald.*

Cole, W.H. *Map and Guide to the Great Serpent Mound, Adams County, Ohio.* Columbus, OH: Press of the F.J. Heer Printing Co., 1925.

Cook, William A. *August "Garry" Herrmann: A Baseball Biography.* Jefferson, NC: McFarland & Co., 2008.

Cooper, Catherine. "Cincinnati's Super Sleuth." *Cincinnati Magazine,* August 1983.

"Cora M. Dow." *Pharmaceutical Era* 48 (November 1915).

Cott, Jonathan. *Wandering Ghost: The Odyssey of Lafcadio Hearn.* New York: Alfred A. Knopf, 1991.

Dellinger, Susan. *Red Legs and Black Sox: Edd Roush and the Untold Story of the 1919 World Series.* Cincinnati, OH: Emmis Books, 2006.

Dennett, Andrea Stulman. *Weird and Wonderful: The Dime Museum in America.* New York: New York University Press, 1997.

Dow, M.C. "Once There Was One Little Store." 25th anniversary pamphlet, 1910.

———. [M.C. Dorr] "Women as Pharmacists." *Proceedings of the American Pharmaceutical Association* 46 (1898).

Doyle, Arthur Conan. *Our Second American Adventure.* London: Hodder and Stoughton, 1924.

Drake, Daniel. *Natural and Statistical View; or, Picture of Cincinnati and the Miami Country, Illustrated by Maps.* Cincinnati, OH: Looker and Wallace, 1815.

———, ed. *The Western Journal of the Medical & Physical Sciences.* Vol. 3. Cincinnati, OH: Whetstone and Buxton, 1830.

Draper, Lyman C. *The Life of Daniel Boone.* Edited by Ted Franklin Belue. Mechanicsburg, PA: Stackpole Books, 1998.

Durrell, Richard H. "A Recycled Landscape." *Quarterly of the Cincinnati Museum of Natural History* 14, no. 2 (May 1977).

Eberle, Scott G. *Classic Toys of the National Toy Hall of Fame.* Philadelphia: Running Press Book Publishers, 2009.

Ehrlinger, David. *The Cincinnati Zoo and Botanical Garden: From Past to Present.* Cincinnati, OH: Cincinnati Zoo and Botanical Garden, 1993.

Elliott, James W. *Transport to Disaster.* New York: Holt, Rinehart and Winston, 1962.

Emerson, Ken. *Doo-dah! Stephen Foster and the Rise of American Popular Culture.* New York: Simon & Schuster, 1997.

Farrell, Richard. "Daniel Drake: The Ohio Valley's Benjamin Franklin." *Cincinnati Historical Society Bulletin* 23, no. 4 (1965).

Filson, John. *The Discovery, Settlement and Present State of Kentucke.* Wilmington, DE: James Adams, 1784.

Flannery, Michael A. *John Uri Lloyd: The Great American Eclectic.* Carbondale: Southern Illinois University Press, 1998.

Fletcher, Robert V., Terry L. Cameron, Bradley T. Lepper, Dee Anen Wymer and William Pickard. "Serpent Mound: A Fort Ancient Icon?" *Midcontinental Journal of Archaeology* 21, no. 1 (1996).

Flint, Timothy, ed. *Western Monthly Review.* Vols. 1, 3. Cincinnati, OH: E.H. Flint, 1828, 1830.

Ganey, Terry. "'I was fast.'" *Columbia Tribune,* August 17, 2008.

Gildea, William. "Hubbard's Long Jump into History." *Washington Post*, June 30, 1996.

Goldin, Claudia, and Lawrence F. Katz. "The Most Egalitarian of All Professions: Pharmacy and the Evolution of a Family-Friendly Occupation." National Bureau of Economic Research, 2012.

Goodwin, Doris Kearns. *Team of Rivals: The Political Genius of Abraham Lincoln.* New York: Simon & Schuster, 2005.

Goss, Charles Frederic. *Cincinnati: The Queen City: 1788–1912.* Chicago: S.J. Clarke Publishing Co., 1912.

Greenberg, Joel. *A Feathered River Across the Sky: The Passenger Pigeon's Flight to Extinction.* New York: Bloomsbury, 2014.

Greenman, Emerson F. *Serpent Mound.* Columbus: Ohio Historical Society, 1970.

Hamilton, Ross. *The Mystery of the Serpent Mound: In Search of the Alphabet of the Gods.* Berkeley, CA: Frog, Ltd., 2001.

Harding, Leonard. "The Cincinnati Riots of 1862." *Bulletin of the Cincinnati Historical Society* 25, no. 4 (October 1967).

Harrison, Lowell H. *George Rogers Clark and the War in the West.* Lexington: University Press of Kentucky, 1976.

Hart, Alfred Bushnell. *Salmon P. Chase.* Boston: Houghton Mifflin Co., 1899; reprint, New York: Chelsea House, 1980.

Haverstock, Mary Sayre, Jeanette Mahoney Vance and Brian L. Meggitt, eds. *Artists in Ohio, 1787–1900: A Biographical Dictionary.* Kent, OH: Kent State University Press, 2000.

Hearn, Lafcadio. *An American Miscellany.* Vol. 1. Edited by Albert Mordell. New York: Dodd, Mead and Co., 1924.

———. *Inventing New Orleans: Writings of Lafcadio Hearn.* Edited by S. Frederick Starr. Jackson: University of Mississippi Press, 2001.

———. *Period of the Gruesome: Selected Cincinnati Journalism of Lafcadio Hearn.* Edited by Jon Christopher Hughes. Lanham, MD: University Press of America, 1990.

———. *Whimsically Grotesque: Selected Writings of Lafcadio Hearn in* The Cincinnati Enquirer, *1872–1875.* 3rd ed. Edited by Cameron McWhirter and Owen Findsen. Roscommon, MI: KyoVision Books, 2011.

Hearn, Lafcadio, and Henry Farny. *Ye Giglampz.* Cincinnati, OH: Crossroads Books and the Public Library of Cincinnati and Hamilton County, 1983.

Heim, Al. "Bengals to Roar in Cincy Again." *Enquirer*, October 28, 1967.

Henderson, Metta Lou and Dennis B. Worthen. "Cora Dow (1868–1915)—Pharmacist, Entrepreneur, Philanthropist." *Pharmacy in History* 46, no. 3 (2004).

Herrmann, Edward W., G. William Monaghan, William F. Romain, Timothy M. Schilling, Jarrod Burks, Karen L. Leone, Matthew P. Purtill and Alan C. Tonetti. "A New Multistage Construction Chronology for the Great Serpent Mound, USA." *Journal of Archaeological Science* 50 (2014).

Hingston, Edward P. *The Genial Showman: Being Reminiscences of the Life of Artemus Ward*. Vol. 1. London: John Camden Hotten, 1870.

"Historic Site Management Plan for Serpent Mound." Ohio History Connection, September 10, 2015.

Holmes, W.H. "Sketch of the Great Serpent Mound." *Science* 8 (December 1886).

Holtz, Allan. "News of Yore 1908: R.F. Outcault Interviewed in Los Angeles." *Stripper's Guide* (blog), October 3, 2011. http://strippersguide.blogspot.com.

Horine, Emmet Field. *Daniel Drake (1785–1852): Pioneer Physician of the Midwest*. Philadelphia: University of Pennsylvania Press, 1961.

Horn, Maurice, ed. *100 Years of American Newspaper Comics*. New York: Gramercy Books, 1996.

Howe, Henry. *Historical Collections of Ohio in Two Volumes: An Encyclopedia of the State*. Cincinnati: State of Ohio, C.J. Krehbiel & Co., 1888; reprint, 1902.

Irwin, Mary Jane. "Compositions of Miss Mary Jane Irwin in the Cincinnati Institute for Young Ladies, 1843." Unpublished.

Juettner, Otto. *Daniel Drake and His Followers*. Cincinnati, OH: Harvey Publishing Co., 1909.

———. "John L. Richmond, Western Pioneer Surgeon." *Lancet-Clinic*, January 27, 1912.

Kasper, Shirl. *Annie Oakley*. Norman: University of Oklahoma Press, 1992.

Kellogg, Elizabeth R. "Joseph Dorfeuille and the Western Museum." *Journal of the Cincinnati Society of Natural History* 22, no. 4 (April 1945).

Kennard, Nina H. *Lafcadio Hearn*. New York: D. Appleton and Co., 1912.

Kenny, D.J. *Illustrated Cincinnati: A Pictorial Hand-Book of the Queen City*. Cincinnati, OH: George E. Stevens & Co., 1875.

Kenton, Edna. *Simon Kenton: His Life and Period 1755–1836*. Salem, NH: Ayer Company Publishers, 1930; reprint, 1990.

King, Arthur G. "The First Caesarian Section in America." *Cincinnati Historical Society Bulletin* 29, no. 1 (1971).

King, W. Ross. *The Sportsman and Naturalist in Canada; or, Notes on the Natural History of the Game, Game Birds, and Fish of that Country*. London: Hurst and Blackett, 1866.

Knepper, George W. *Ohio and Its People.* Kent, OH: Kent State University Press, 2003.

Knight, A.L. "Life and Times of Jesse Bennett, M.D., 1769–1842." *Southern Historical Magazine* 2, no. 1 (July 1892).

Kraft, Joy W. *The Cincinnati Zoo and Botanical Garden.* Charleston, SC: Arcadia Publishing, 2010.

———. "Martha, Last of Her Kind, Died at Zoo." *Enquirer,* August 25, 2013.

Kreidler, A.G., and Charles H. Castle, eds. *The Lancet-Clinic: A Weekly Journal of Medicine and Surgery.* Vol. 52. Cincinnati, OH: Lancet-Clinic Publishing Co., 1912.

"Lafayette's Landing at Cincinnati," *Western Monthly Review,* February 1830.

Lawson, Earl. "Brown's New Club Recalls Old Bengals." *Cincinnati Post & Times-Star,* November 3, 1967.

Lloyd, John Uri. *Etidorhpa; or, The End of Earth.* 2nd ed. Cincinnati, OH: Robert Clarke, 1896; reprint, Albuquerque, NM: Sun Publishing Co., 1976.

———. "A Pharmaceutical Apprenticeship in America Fifty Years Ago." *Journal of the American Pharmaceutical Association* 4 (November 1915).

Lytle, William. "Personal Narrative of William Lytle." *Quarterly Publication of the Historical and Philosophical Society of Ohio* 1, no. 1 (January–March 1906).

MacLean, J.P. "The Great Serpent Mound." *American Antiquarian* 7, no. 1 (January 1885).

Marschall, Richard. *America's Great Comic-Strip Artists: From the Yellow Kid to Peanuts.* New York: Stewart, Tabori & Chang, 1997.

McCay, Winsor. *The Best of Little Nemo in Slumberland.* Edited by Richard Marschall. New York: Stewart, Tabori & Chang, 1997.

McClellan, George B. *The Civil War Papers of George B. McClellan: Selected Correspondence, 1860–1865.* Edited by Stephen W. Sears. Boston: Da Capo Press, 1989.

Mershon, W.B. *The Passenger Pigeon.* New York: Outing Publishing Co., 1906.

Murdock, Eugene. *Ban Johnson: Czar of Baseball.* Westport, CT: Greenwood Press, 1982.

Murray, Jack. "Early Days of Pro Football." *Enquirer,* November 23, 1969.

Neff, William Howard. "The Siege of Cincinnati by a Pearl St. Rifle." Edited by Louis L. Tucker. *Bulletin of the Historical and Philosophical Society of Ohio* 20, no. 4 (October 1962).

Niven, John. *Salmon P. Chase: A Biography.* New York: Oxford University Press, 1995.

Oakley, Annie. "The Story of My Life." National Enterprise Association Service. Serialized in newspapers nationwide, 1926.

Olson, Richard D. "'Say! Dis Is Grate Stuff!': The Yellow Kid and the Birth of the American Comics." *Syracuse University Library Associates Courier* 28, no. 1 (Spring 1993).

Osler, William. *Aequanimitas.* 2nd ed. Philadelphia: P. Blakiston's Son & Co., 1910.

Palmer, John M. *Personal Recollections of John M. Palmer: The Story of an Earnest Life.* Cincinnati, OH: Robert Clarke Co., 1901.

Piatt, Donn. *Memories of the Men Who Saved the Union.* New York: Belford, Clarke & Co., 1887.

Potter, Jerry O. *The* Sultana *Tragedy: America's Greatest Maritime Disaster.* Gretna, LA: Pelican Publishing Co., 1992.

Prothero, Stephen. *Purified by Fire: A History of Cremation in America.* Berkeley: University of California Press, 2001.

Putnam, F.W. "The Serpent Mound of Ohio." *Century Magazine* (April 1890).

Read, T. Buchanan. "The Siege of Cincinnati." *Atlantic Monthly* 11, no. 64 (February 1863).

"Revolutionary Reminiscence of Throwing the Tea Overboard in Boston Harbour." *Western Monthly Review,* July 1927.

Rhodes, Greg, and John Snyder. *Redleg Journal: Year by Year and Day by Day with the Cincinnati Reds Since 1866.* Cincinnati, OH: Road West Publishing, 2000.

Rhodes, Richard. *John James Audubon: The Making of an American.* New York: Alfred A. Knopf, 2004.

Richmond, John L. "History of a Successful Case of Casarean [*sic*] Operation." *Western Journal of the Medical & Physical Sciences,* January–March 1830.

Robertson, Lawson. "Hubbard Off Form, Says Olympic Coach, Who Had Expected Better Results." *Enquirer,* July 9, 1924.

———. "Negro Athlete Is Out." *Enquirer,* July 10, 1924.

Romain, William F. *Mysteries of the Hopewell: Astronomers, Geometers, and Magicians of the Eastern Woodlands.* Akron, OH: University of Akron Press, 2000.

Salecker, Gene Eric. *Disaster on the Mississippi: The* Sultana *Explosion, April 27, 1865.* Annapolis, MD: Naval Institute Press, 1996.

Schorger, A.W. *The Passenger Pigeon: Its Natural History and Extinction.* Madison: University of Wisconsin Press, 1955.

Schurz, Carl. *The Reminiscences of Carl Schurz.* Vol. 2, *1852–1863.* London: John Murray, 1909.

Sears, Stephen W. *George B. McClellan: The Young Napoleon.* New York: Ticknor & Fields, 1988.

Squier, E.G., and E.H. Davis. *Ancient Monuments of the Mississippi Valley.* New York: Bartlett & Welford, 1848.

Starr, S.F. [Stephen Frederick]. "The Archaeology of Hamilton County, Ohio." *Journal of the Cincinnati Museum of Natural History* 23, no. 1 (June 1960).

Stern, Joseph S., Jr. "The Siege of Cincinnati." *Bulletin of the Historical and Philosophical Society of Ohio*, no. 18 (July 1960).

Stevenson, Elizabeth. *The Grass Lark: A Study of Lafcadio Hearn.* 2nd ed. New Brunswick, NJ: Transaction Publishers, 1999.

Styple, William B. *McClellan's Other Story: The Political Intrigue of Colonel Thomas M. Key, Confidential Aide to General George B. McClellan.* Kearny, NJ: Bell Grove Publishing Co., 2012.

Tenkotte, Paul A., James C. Claypool and David E. Schroeder, eds. *Gateway City: Covington, Kentucky 1815–2015.* Covington, KY: Clerisy Press, 2015.

Thatcher, Benjamin Bussey. *Traits of the Tea Party; Being a Memoir of George R.T. Hewes, One of the Last of Its Survivors.* New York: Harper & Brothers, 1835.

Thorpe, Francis Newton, ed. *The Federal and State Constitutions, Colonial Charters and Other Organic Laws of the States, Territories, and Colonies Now or Heretofore Forming the United States of America.* Vol. VII. Washington, D.C.: Government Printing Office, 1909.

Trollope, Frances. *Domestic Manners of the Americans.* Edited by Donald Smalley. New York: Alfred A. Knopf, 1949.

Turzillo, Jane Ann. *Murder & Mayhem on Ohio's Rails.* Charleston, SC: The History Press, 2014.

Venable, W.H. *Beginnings of Literary Culture in the Ohio Valley.* Cincinnati, OH: Robert Clarke & Co., 1891.

Vonderhaar, Donna. "Becoming Numero Uno." *Enquirer*, August 17, 1980.

Wall, Caleb A. *The Historic Boston Tea Party of December 16, 1773.* Worcester, MA: F.S. Blanchard & Co., 1896.

Wallace, Lew. *Lew Wallace: An Autobiography.* Vol. 2. New York: Harper & Brothers Publishers, 1906.

Walsh, Tim. *The Playmakers: Amazing Origins of Timeless Toys.* Sarasota, FL: Keys Publishing, 2004.

Williams' Cincinnati Directory. Cincinnati, OH: Williams Directory Co., 1848–1941.

Willoughby, Charles C. "The Serpent Mound of Adams County, Ohio." *American Anthropologist* 21 (1919).

Wimberg, Robert J. *Cincinnati and the Civil War: Under Attack!* Cincinnati: Ohio Book Store, 1999.

Worthen, Dennis B. "John Uri Lloyd 1849–1936: Wizard of American Plant Pharmacy," *Journal of the American Pharmaceuticals Association* 49, no. 2 (March–April 2009).

Wright, G. Frederick. *Representative Citizens of Ohio.* Cleveland, OH: Memorial Publishing Company, 1915.

Wright, Kelly F., ed. "Henry Bellows Interviews Hiram Powers." *Ohio Valley History* 4, no. 3 (Fall 2004).

NEWSPAPERS AND MAGAZINES

Boston Gazette
Boston News-Letter & City Record
Charlotte Observer
Cincinnati Commercial
Cincinnati Enquirer
Cincinnati Gazette
Cincinnati Magazine
Cincinnati Post
Cincinnati Times
Cincinnati Times-Star
Cleveland Plain Dealer
Columbia Tribune
Daily Cincinnati Gazette
Daily (Greencastle, IN) Banner Times
Dayton Sunday Journal
Lancet-Clinic
London Magazine
Morning Courier and New York Enquirer
New York Herald
New York Journal
New York World
Pharmaceutical Era
Pittsburgh Dispatch
Pittsburgh Press
Troy (OH) Times
Washington Post

Western Monthly Review
Ye Giglampz

OTHER

Ancestry.com.

The Billy Ireland Cartoon Library & Museum at Ohio State University. cartoons.osu.edu.

Boston 1775 blog. boston1775.blogspot.com.

Centers for Disease Control and Prevention. www.cdc.gov.

Cincinnati History Library and Archives. library.cincymuseum.org.

Cincinnati Museum Center. cincymuseum.org.

Disneyland. "The Story of the Animated Drawing" episode. Broadcast November 30, 1955.

Greater Cincinnati Police Historical Society Museum. www.gcphs.com.

History.com.

The Kenner Toy Story: Cincinnati, Ohio, 1946–2000. Video produced by Corky Steiner.

Library of Congress. www.loc.gov.

Lloyd Library and Museum. www.lloydlibrary.org.

National Audubon Society. www.audubon.org.

Newspapers.com.

Ohio History Central. www.ohiohistorycentral.org.

Ohio History Connection. www.ohiohistory.org.

National Football League. www.nfl.com.

Pro-Football-Reference.com. www.pro-football-reference.com.

ProQuest Historical Newspapers.

Public Library of Cincinnati and Hamilton County. cincinnatilibrary.org.

Smithsonian Institution. www.si.edu.

Society for American Baseball Research. sabr.org.

This Great Game: The Online Book of Baseball. www.thisgreatgame.com.

The United States Playing Card Company. www.bicyclecards.com.

William Dickson Papers, William L. Clements Library, The University of Michigan.

The William F. Cody Archive. codyarchive.org.

ABOUT THE AUTHOR

J eff Suess is the author of *Lost Cincinnati* (The History Press) and the librarian of the *Cincinnati Enquirer*, where he keeps the newspaper archive and writes about Cincinnati history. He regularly does presentations on local history and leads discussions on graphic novels at the Mercantile Library and the Public Library of Cincinnati and Hamilton County. Jeff also writes fiction and has had stories published by Pocket Books, Post Mortem Press and DC Comics.

Jeff grew up in Modesto, California, and graduated from San Francisco State University. He lives in White Oak on Cincinnati's West Side with his wife, Kristin, and their daughter, Dashiell.

Visit us at
www.historypress.net
..
This title is also available as an e-book